A BROKEN LANDSCAPE HIV & AIDS IN AFRICA

A BROKEN LANDSCAPE GIDEON MENDEL

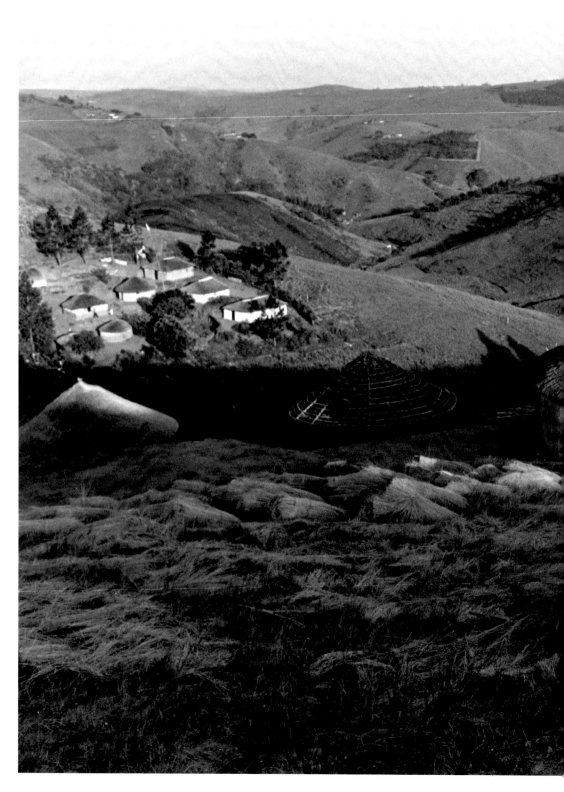

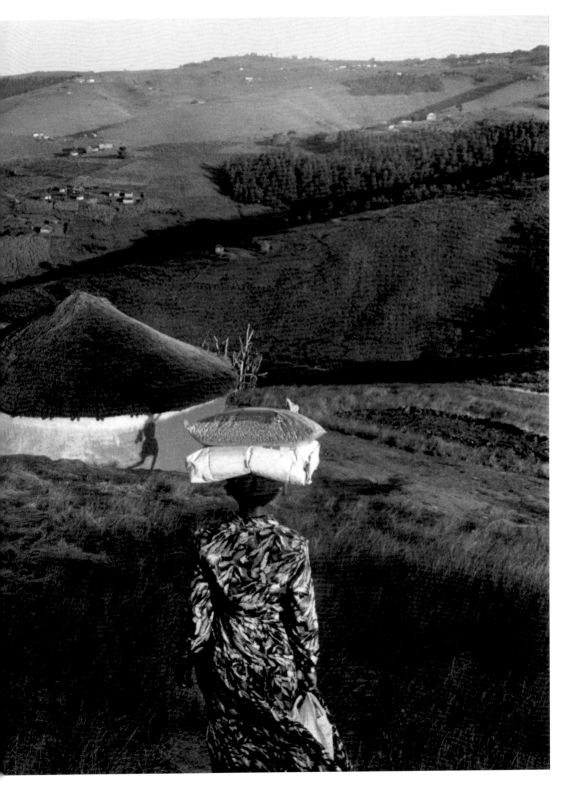

Noerine Kaleeba. Introduction

My personal involvement with HIV began on a June day in 1986 when the virus entered my front door. One year later, the disease had taken my husband, leaving my four daughters and me to struggle with the social ills of this epidemic. Since founding The AIDS Support Organisation in 1987, I have faced the numerous questions that HIV and AIDS force our world to confront, such as openness, compassion and how to deal with a global problem.

AIDS is the most devastating epidemic in history. Since 1982, over 22 million people have lost their lives to AIDS and over 36 million people worldwide are living with HIV and AIDS. Globally, therefore, approximately one person in every 100 aged between 15-49 is HIV positive. Many breadwinners and parents of young children die before they reach 35. It is estimated that over 90% of people will die not knowing they had contracted HIV – or whether they have passed the virus on. The impact of the epidemic on humanity will be devastating if AIDS is left unchecked.

Ninety-five per cent of people who have died from AIDS lived in the developing world – almost 15 million of them in Sub-Saharan Africa. The stark facts are that someone is dying of an AIDS-related illness every 15 seconds in Africa. The implications for the continent are immense. Increasing illness and deaths from AIDS is reversing decades of development at all levels of society.

In Africa there are now over 12 million children living in AIDS-affected households or struggling to survive after the death of one or both parents. The young adult population is shrinking rapidly. Increased demand for healthcare is already overstretching public health systems. In recent years HIV positive patients have occupied half the beds in big city hospitals in Burundi and Kenya. In education AIDS is eroding the

supply of teachers. For example, in the Central African Republic, 85% of the teachers who died between 1996 and 1998 were HIV positive.

The effect on agriculture and business can be seen in one sugar cane estate which reported a 50% drop in production, higher overtime costs, a five-fold increase in funerals and a ten-fold increase in health costs. At the other end of the scale, when a poor farmer falls ill the effects are devastating. The family loses income from cash crops and has to buy food, selling equipment and household goods to survive. Children are taken out of school to work and help support these additional needs.

I have come to know AIDS very well. For me the statistics mean friends, family, neighbours and colleagues. I remember their stories, their struggles and, most importantly, their courage. This is what drives my work. This is what makes me realise that we all need to hear the stories of the people who are dying and living with HIV and AIDS.

A Broken Landscape tells us the story of AIDS in Africa. It shows us what is driving this human tragedy and the strength and capacity of the women, men and children coping with unimaginable problems.

Africa is dealing with the huge and costly consequences of HIV and poverty locked together in a downward spiral of deprivation and despair. Poor and malnourished people, whose immune systems are already weak, can succumb more easily. They cannot earn money and all their nutritional and health needs increase. Often they can afford neither food nor treatment.

While the number of people infected by the virus amounts to around 25 million in Africa, it impacts on over 150 million African women, men

and children. Women bear the brunt of the responsibility of caring for those who are sick and those that are left behind. Grandmothers are watching their sons and daughters die and are left to deal with the emotional and economic care of their grandchildren.

Women and children have been robbed of their inheritance rights. Their economic powerlessness and lack of choices makes them more at risk and it is this inequality that is one of the strongest factors driving this epidemic. Women are also more likely to be infected than men. There are an estimated 13.3 million women living with AIDS in Africa compared to 10.9 million men. I worry about my daughters and other younger women being increasingly vulnerable to rape and sexual abuse as they are perceived as being free from HIV.

AIDS feeds on inequality, ignorance, fear and blame. The stigma and negative attitudes within communities and the workplace experienced by people infected with HIV and AIDS increases discrimination.

My first encounter with a person living with AIDS was very brief but is vivid in my mind. I was at Mulago Hospital demonstrating how to transfer a paraplegic from a bed to a wheelchair. A young man – not more than 30 years old – gave permission for my students to learn from him. His medical notes indicated that he had paraplegia due to immunosuppression syndrome, but I was unfamiliar with the diagnosis.

I later asked the ward nurse about the scheduling of the demonstration. She warned me 'I wouldn't touch him if I were you. He has AIDS. We don't touch him, we only show his mother what to do'. I cancelled the class and arranged for another patient volunteer without ever giving the young man an explanation. I did not think of him again until my husband was diagnosed with AIDS. I still wonder what happened to

him and whether he and his mother had anyone to support them. I suppose I will never know.

What I do know is that discrimination drives people to secrecy and denial. The fear of being ostracised by family and neighbours, along with the risk of losing jobs, continues to confound and complicate efforts to deal with this epidemic. We all have a role to play in creating openness and respect which are crucial in this fight.

That is why this book is so important. Here you see the risks that people have taken by disclosing their HIV status. Their phenomenal courage in sharing how HIV affects their lives is their legacy to give meaning to their suffering and their bravery. I would like to pay a tribute to their openness and fortitude in choosing to share very personal images and thoughts of their situation.

Having worked in the field of HIV/AIDS for 15 years, I have seen Uganda's success. I have learned many lessons about what works and what doesn't, and I know we are now faced with one of the greatest challenges in history – to provide life and hope for future generations in the face of this epidemic.

HIV can be prevented, and this must be our priority. Prevention is not just about providing information and condoms, it's also about strengthening communication skills and openness in personal and professional relationships. We have to find a way for people in the developing world to get the drugs that have turned AIDS into a manageable, chronic illness rather than a death sentence. We have to make sure that people have access to testing centres.

So, how do we make this happen? To succeed we have to move away

from blame – whether at an individual or national level – to a situation where there is a shared global responsibility. At an individual level we need to change our behaviour and attitudes, particularly about stigma and discrimination. At a national level we have to ensure that governments provide effective leadership and fulfil commitments they have made. At an international level we have to address the imbalance of power and resources between the developed and developing worlds.

I have experienced a great deal of pride in watching the Ugandan people, and Africans in general, move away from paralytic shock to an organised, positive response to the disease. I see effective ways that people, volunteers and professionals, are helping to relieve the effects of the epidemic. But most are small and urgently need scaling up.

The most important lesson that I have learned is that it is vital to be open with people, to share skills, work in partnership, and to make certain that people living with and affected by HIV are at the centre of our responses. We must create an environment which will encourage people living with AIDS to openly seek, support and participate in collective action.

A Broken Landscape gives us an insight into real lives. It is these stories that can help us understand the daily impact of this virus. Because at the centre of this epidemic alongside all the suffering, grief and pain, there is hope, laughter and courage. It is this strength and tenacity that is going to help us overcome.

Joseph Gabriel. Mwanza, Tanzania

Joseph is cared for at home by his mother Dorika and his 12-year-old brother Daniel.

I have been sick for 10 years now.

I wake up in the morning and drink my tea. My brother washes me. When it is warm and dry like today I spend my days sitting outside my house under the shade my brother made. My mother or my brother carry me here in the morning and I stay here until the afternoon. I like listening to the radio – the music, the football and the news I enjoy. Sometimes I get money for the battery from my brother which he earns from cleaning shoes at a stall outside the house. My friends pass by and tell me how their lives are going. They read the bible together with me.

At the moment my life is rich. I have no pain. My belief in God makes me happy and I have the love and care of my family.

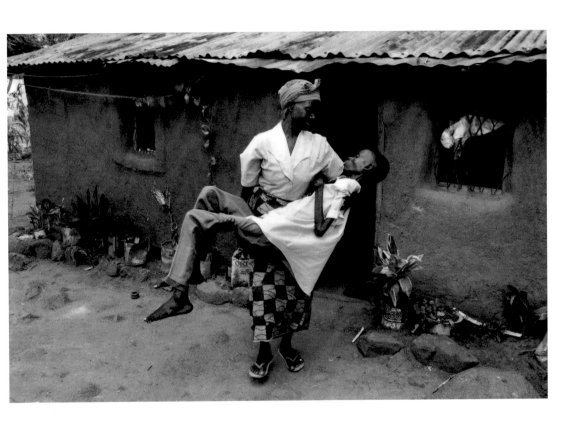

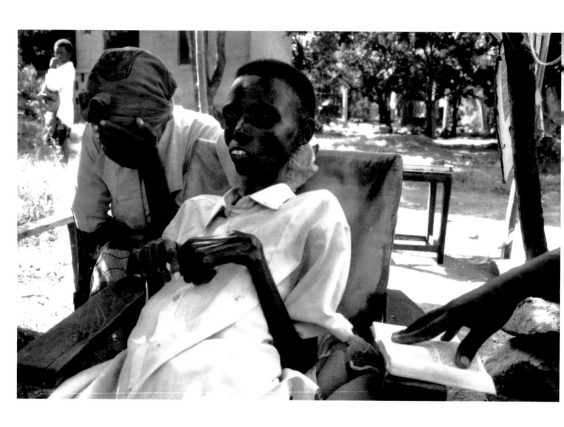

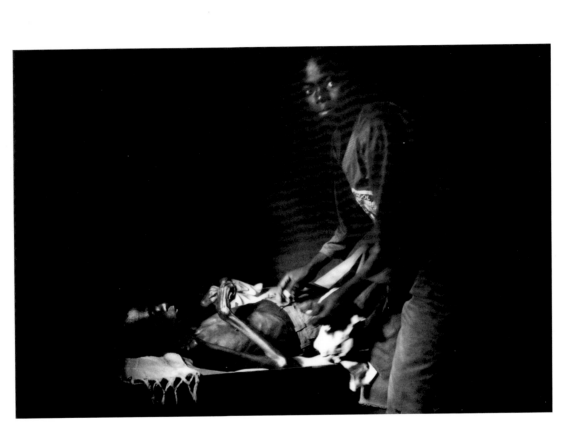

Martha Mukaratirwa. Headlands, Zimbabwe

Martha cares for her daughter Eva at home.

My day starts at six o'clock in the morning when I wake up and sweep the yard. I go to fetch water and then prepare porridge for Eva's breakfast. I wash the dishes and do the laundry and work in the garden. I feed Eva her lunch at one o'clock. I bathe her after lunch and then I have a nap. When I wake up I give Eva a drink and then put her to bed. I need to check a lot on her during the night because I have to change her bedding.

I was very heartbroken when my son-in-law came to abandon my daughter here. At that time my daughter had a baby and could hardly walk. My son-in-law did not leave even a cent for her to see the doctor. He has another wife and another child aged two. He occasionally comes to visit but he comes empty handed, even though he is quite aware of the food shortages in this household. Sometimes I get money from two of Eva's brothers working in Harare.

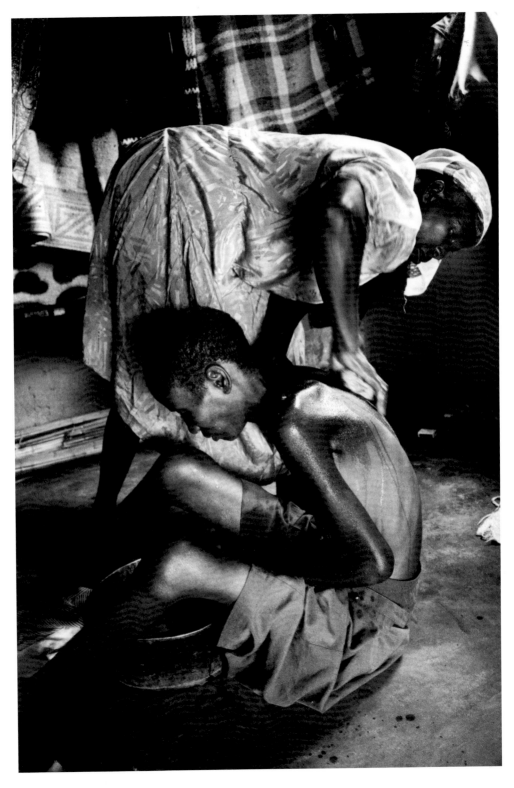

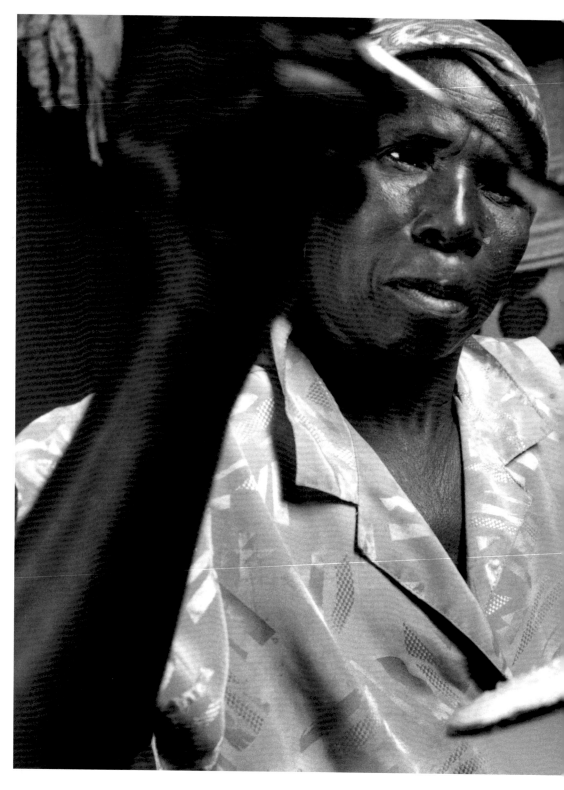

Wiseman Thabede. Enseleni Township, South Africa

Wiseman is taken to the Ngwelezane Hospital AIDS clinic by his grandmother Elenena Myeni who is also HIV positive and a local AIDS activist.

I have been sick for about a year now. I was studying electrical engineering at a technical college in Newcastle. I had to leave the course because I was sick. In March this year I was tested and found that I had HIV.

When I can, I come to stay with a traditional healer. He prays for me and warms and blesses water that he puts over my whole body. I had a big ulcer on my back and the healer applied herbs that took the sore away. Lots of people come to this healer, especially the ones who are sick like me. Traditional medicine is better for me than the hospital. The healer allows me to drink hospital medicines for my TB. He prays to God, not the ancestors, for the cure. He will be able to make me better but he will not be able to cure the virus.

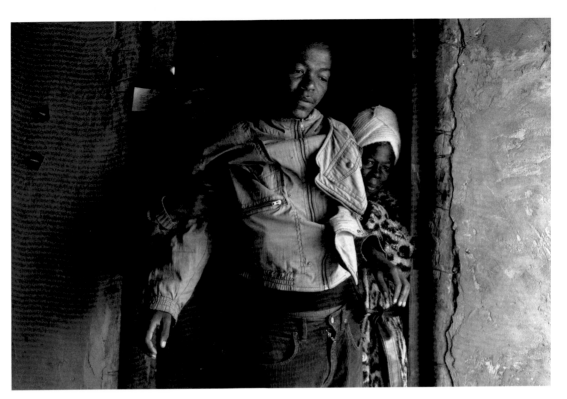

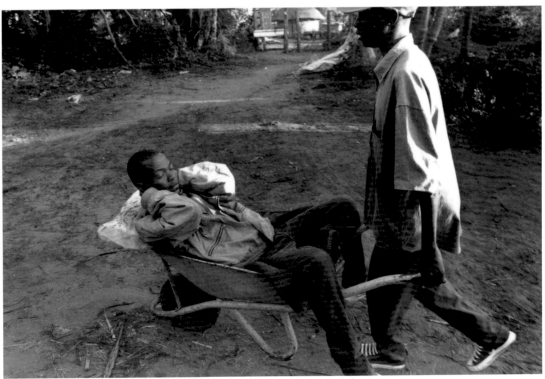

Samkelisiwe Mkhwanazi. Ngwelezane, South Africa

Samkelisiwe is cared for by her mother Nesta.

My daughter Samkelisiwe has recurring TB which won't be cured. She has been tested and has found out that she has AIDS. She has decided to disclose her status to the community to help educate others and I support her because I love and respect her.

Life is very difficult because I have a pension of 500 Rand per month. With that I have to support my two daughters Nomhlahla and Samkelisiwe who are ill, my other two other children who are unemployed and seven grandchildren who I take care of. Nomhlahla has three children and Samkelisiwe has one. At my age of 59 it is hard to be a mother once again to all these children, but I try to give them all the love that I have.

If I have one wish in the world it is that my children will be well and not die young.

NESTA MKHWANAZI

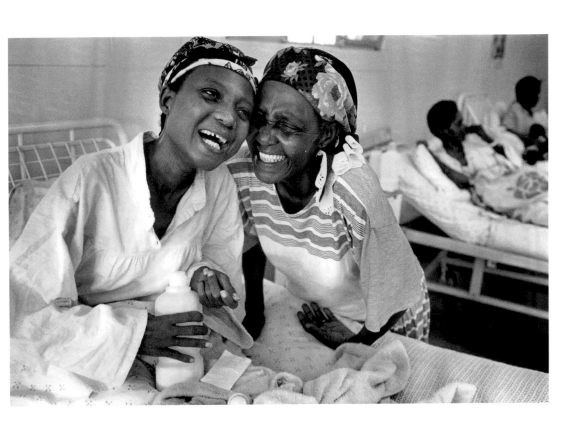

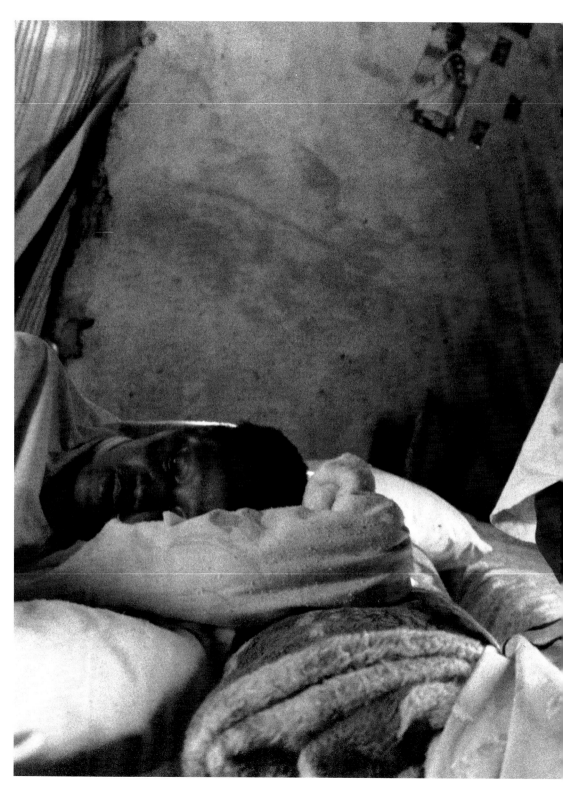

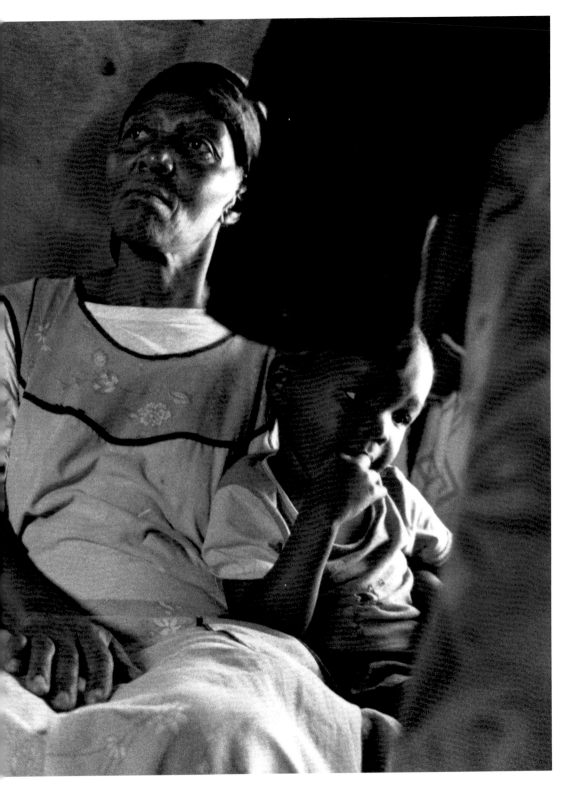

I have been very ill since December last year. I was diagnosed with TB and admitted at Ngwelezane Hospital. It was very bad and I was in hospital for three weeks. While I was there I was counselled and diagnosed with HIV. I went to a traditional healer. I stayed with him for three months. I was treated with herbs and water and herbal medicine, but there didn't seem to be any effect.

I love my mother. With all the problems that I face, when she holds me and takes care of me I feel that she is the solution. I was born in 1973 and normally I would be the one taking care of my mother, but now I am the baby again. She is looking after everyone in the family. Also since my sister died on the 3rd of June, she is looking after her children. She will take care of my child. I want to be with her until I die.

SAMKELISIWE MKHWANAZI

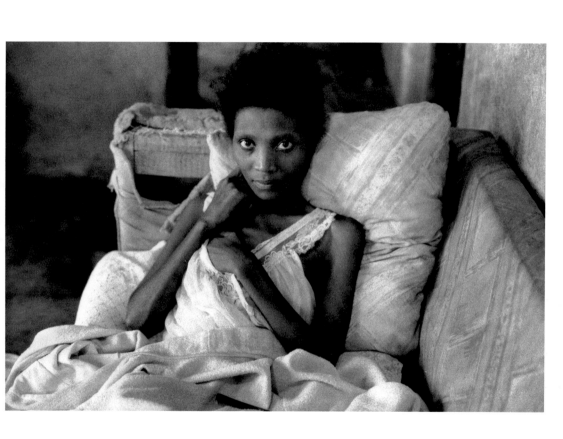

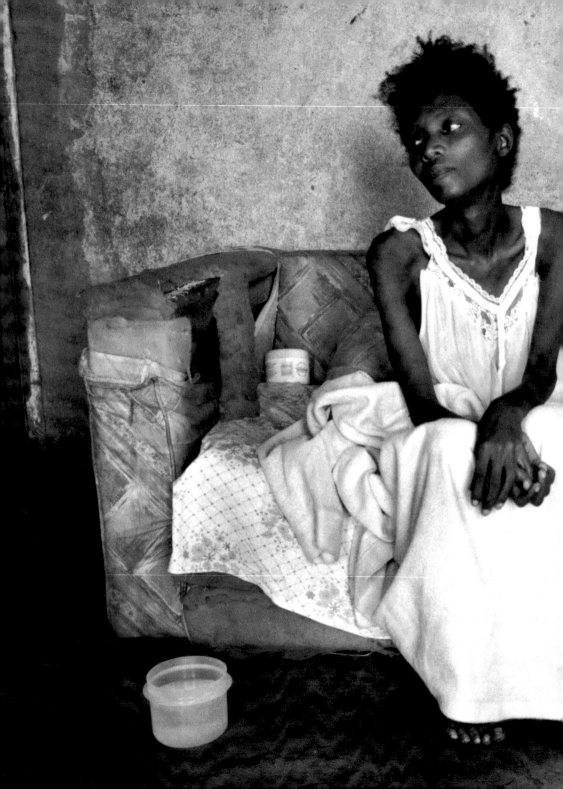

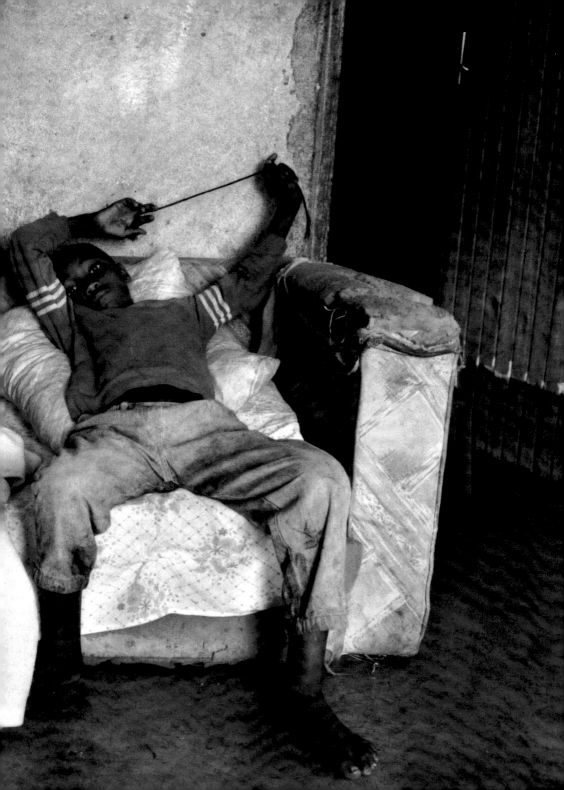

Mission hospital. Matibi, Zimbabwe

A remote rural hospital in an area where nearly 30% of pregnant women test HIV positive.

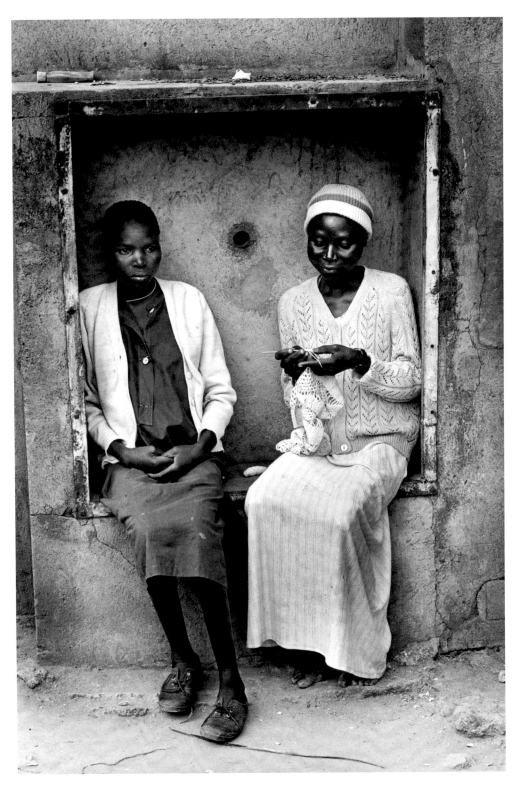

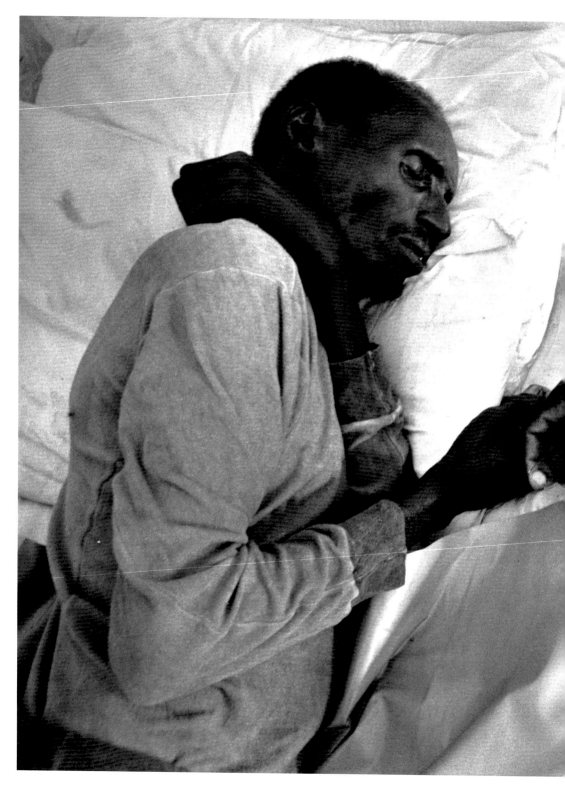

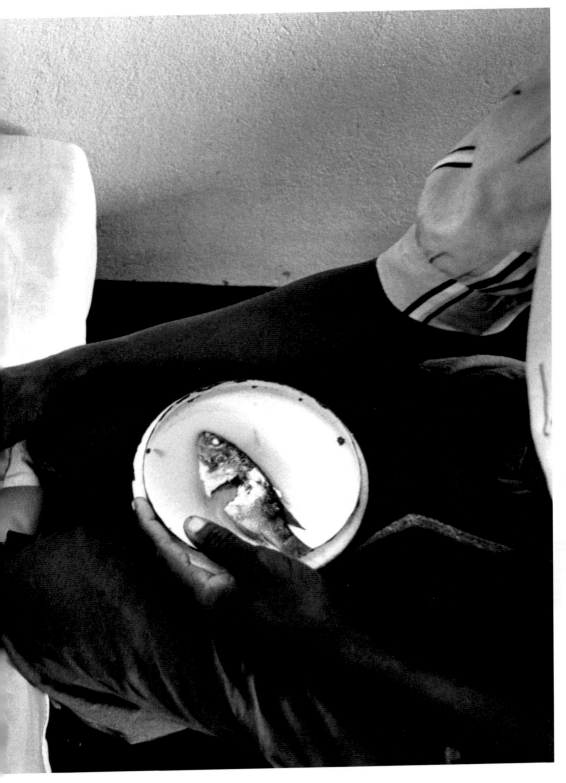

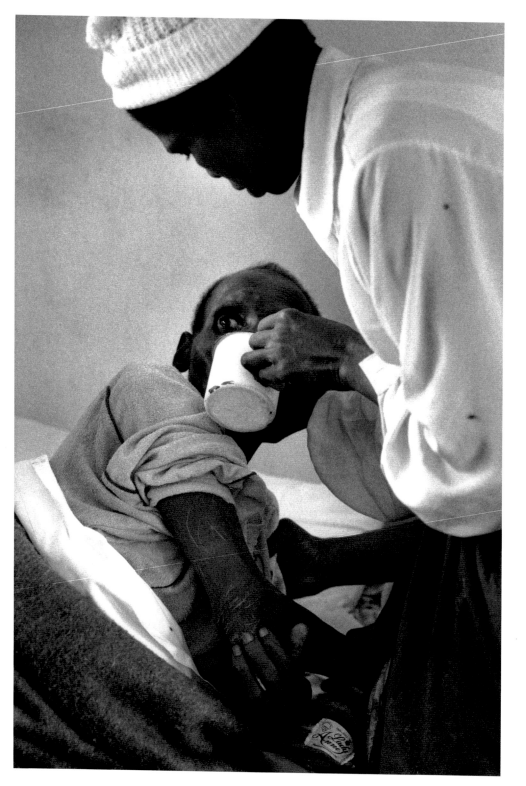

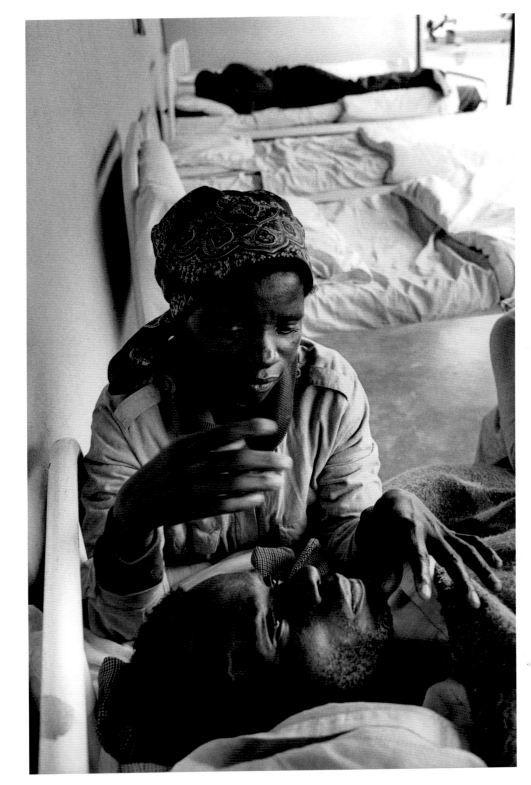

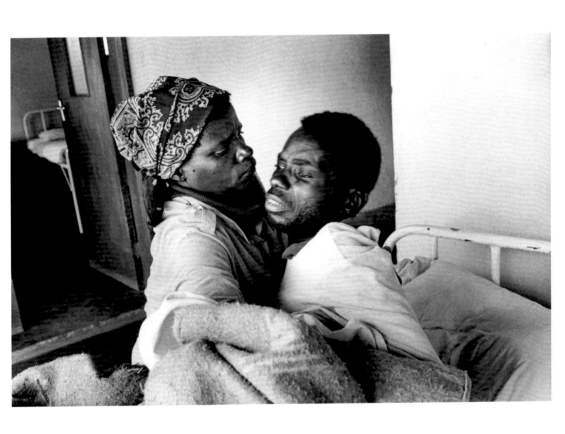

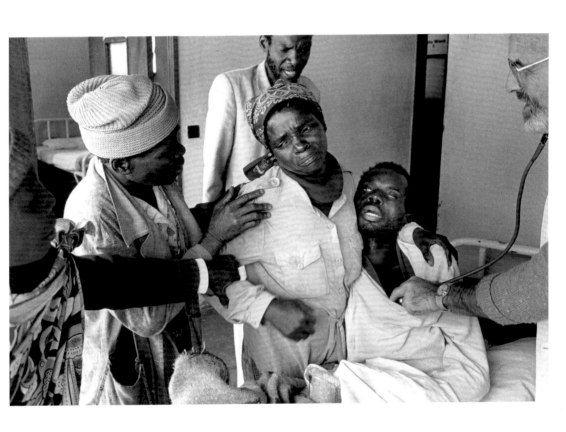

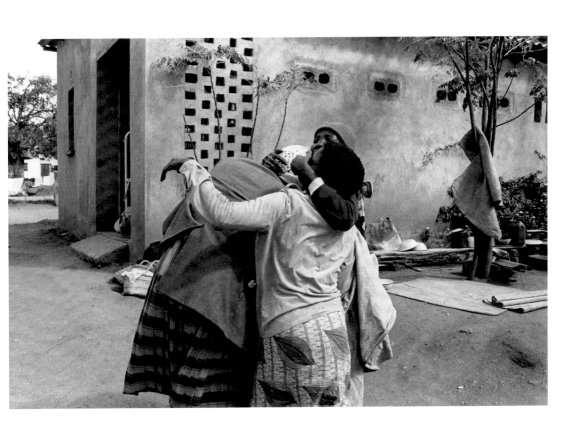

Hospitals. KwaZulu-Natal, South Africa

Ngwelezane, Hlabisa and Edendale hospitals are in the
province of South Africa with the highest incidence of HIV/AIDS.

This hospital has 604 beds and half of our 700 admissions per month are HIV related. In March 2000, 733 people at the hospital were tested for HIV and 461 were positive. The incidence of tuberculosis has doubled over the past three years. We don't sees new conditions so much; rather, existing diseases affect people far more seriously. Before, we would expect to discharge patients with TB after five to ten days to resume work but now many are too weak to even feed themselves. We lose between one and three staff a month from HIV.

Denial is a big issue. Patients often go from hospital to hospital hoping someone will treat them without realising they are HIV positive. Or they wait until they are severely ill before coming for treatment. This all sounds so depressing but I get a lot of strength from the homecare staff, as well as from the patients who attend the HIV follow-up clinic. Those who accept an AIDS diagnosis, have a positive attitude and the strength to fight back survive much longer than those who don't.

DR PETER HASELAU, DIRECTOR, NGWELEZANE HOSPITAL

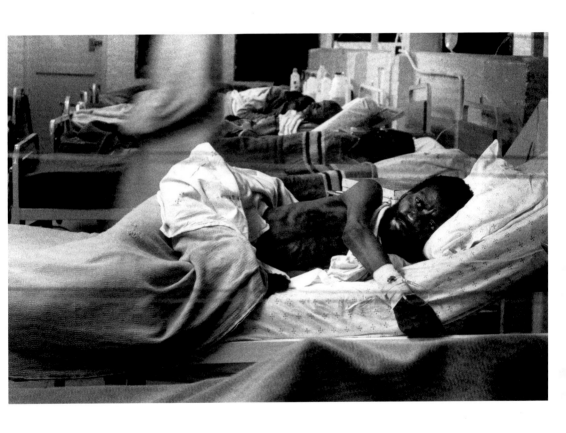

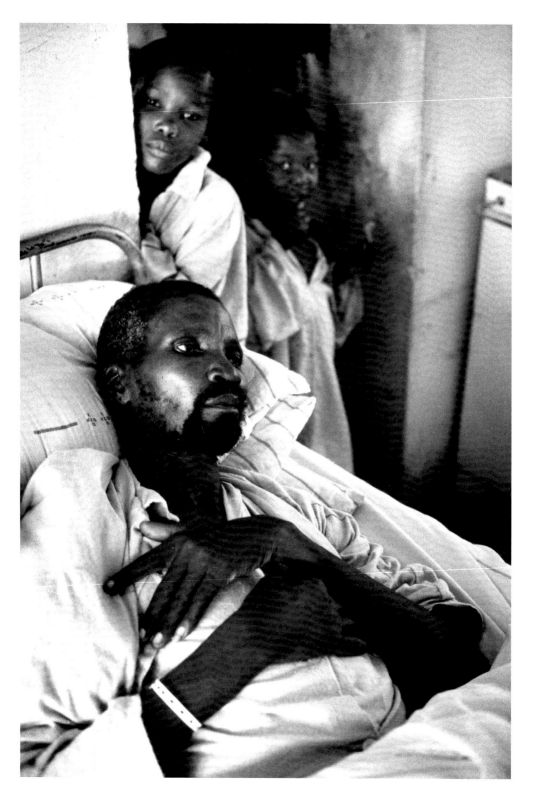

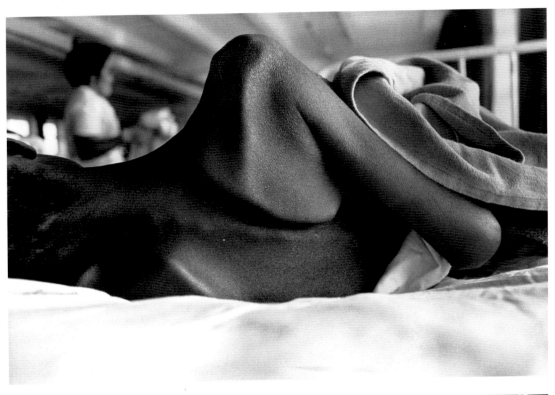

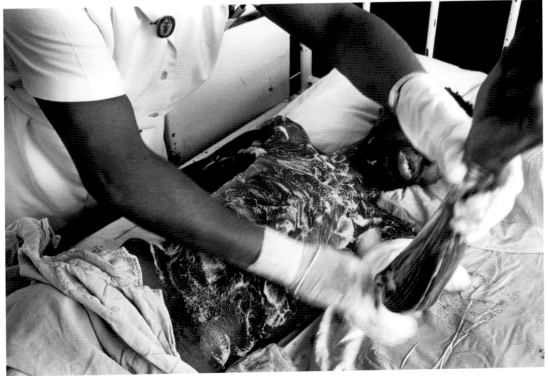

Government hospital. Nkhotakota, Malawi

35-40% of patient illness at the hospital is AIDS-related.

Officially we have beds for 110 patients, but we now have about 130 patients and 250 outpatients a day. It's difficult to say accurately how many have died of AIDS because we have run out of reagent for testing and haven't been able to test. We have approximately one death a day.

We lack equipment, we lack staff, we don't have medicines. We don't even have plaster tape, so we have to use masking tape to attach drips or splints to patients' arms. We are overwhelmed in every aspect of the epidemic.

DR MAURICE BONONGWE, DIRECTOR

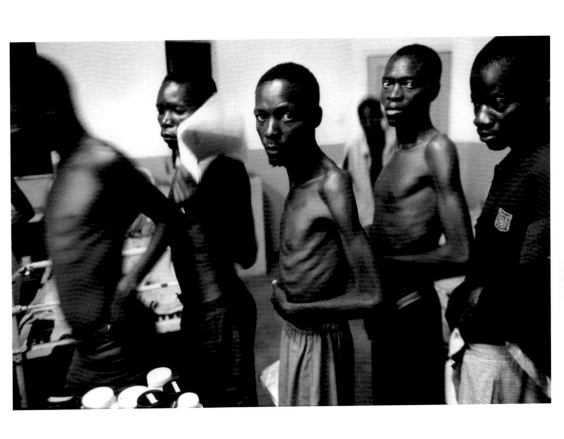

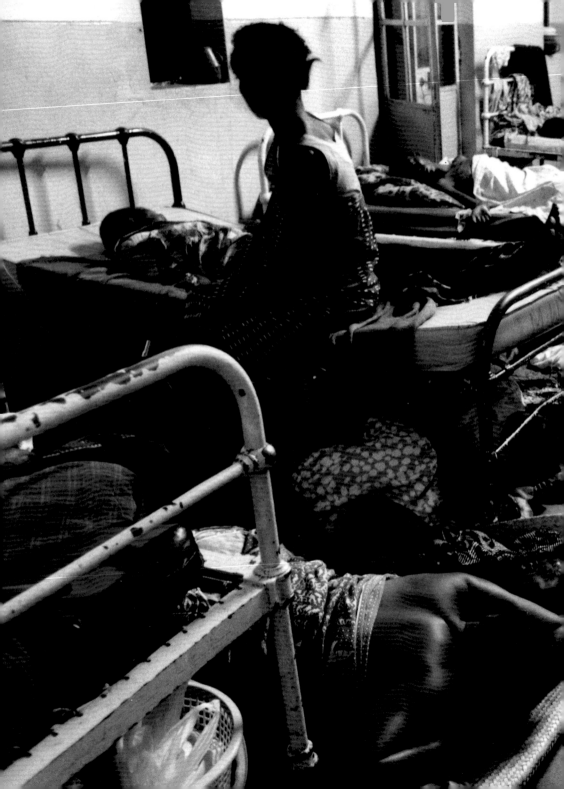

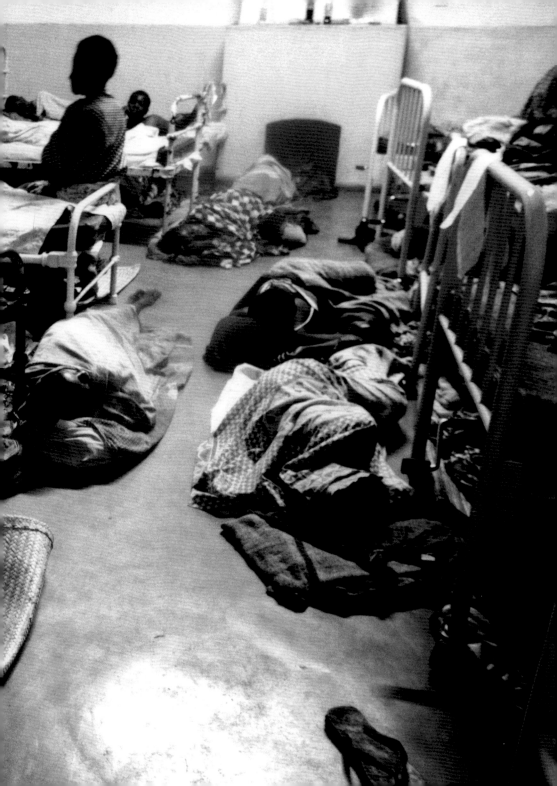

Eliza Myeni. Nkhotakota, Malawi

Eliza, a 19-year-old student, died at the hospital in Nhkotakota
in November 2000.

Eliza was the daughter of my younger sister
Efrieda who died in 1994. Her father James who
was a store clerk died last year. She had been in
Form 2 at school in Mzuzu, but when she fell ill
she came to stay here at the home of her
grandfather in Selemani Village as she did not
have parents to care for her any more. She got
very sick and was in the hospital for a month.
With my other sisters I stayed there taking care
of her as well as we could. She was vomiting a lot
and became very thin but we tried to get her to
eat just a bit of maize porridge. She had a big
cough and then she died in the middle of the
night. I was there with her and she just held
my hand tight. God protected her and then he
wanted her.

JANE CHIWRA

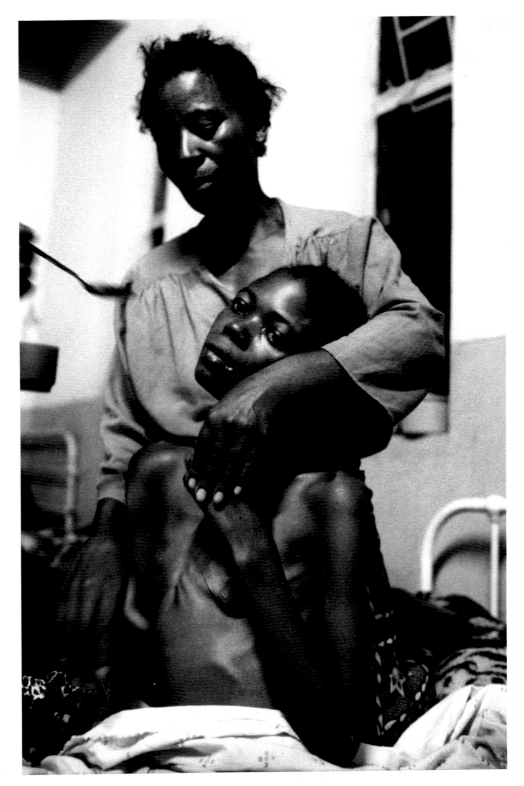

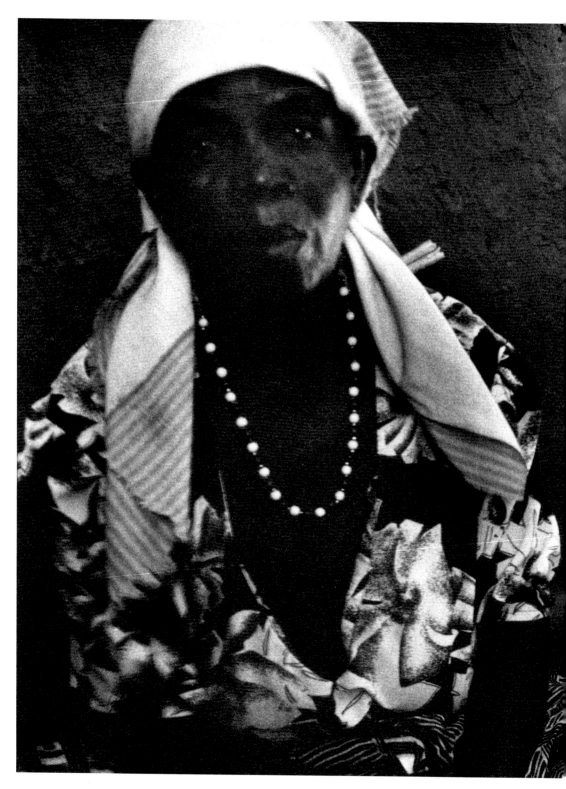

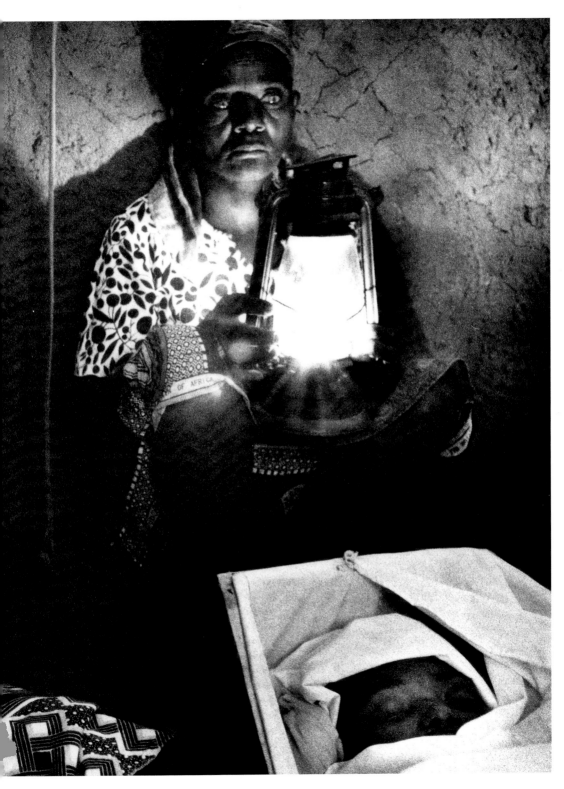

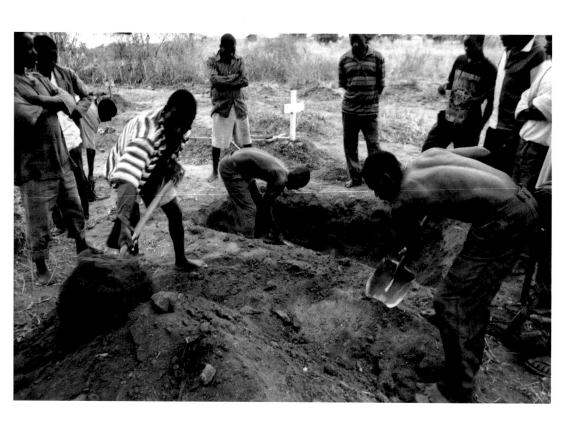

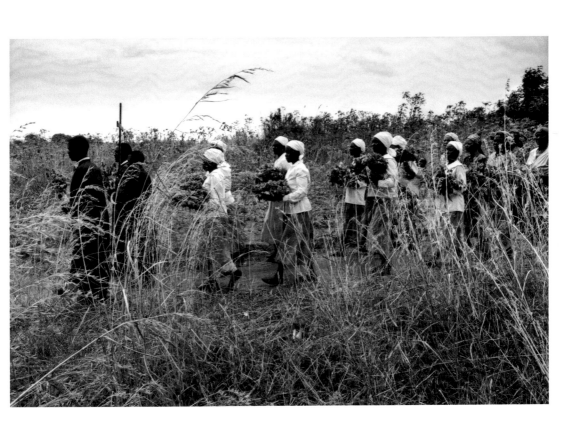

Miriam Mbwana. Nkhotakota, Malawi

Miriam nurses her daughter Mary. Mary died in November 2000.

In my life I have had 11 children, eight girls and three boys. Seven have passed away. The first, Lawrence, died in 1993 and one of my children has died every year since. Another six of my grand-children have died. AIDS has carried my family away like a flood.

I look after 16 of my children's children. My granddaughter Madrin is in hospital with her son John, and they are both very weak. She has lost three children already. My daughter Mary now is very ill. We are very close. She is my best friend.

What have we done to deserve this? My father used to say 'When death is there, pass by on the other side.' But it's not possible now. Death is everywhere.

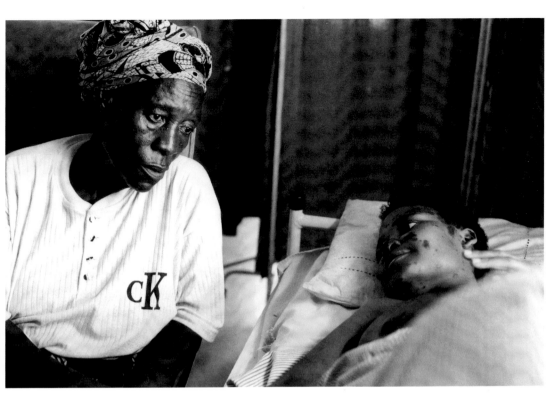

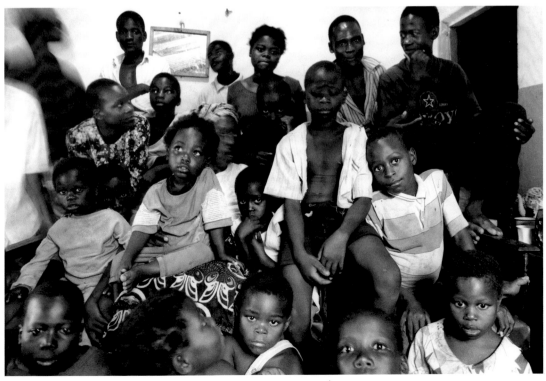

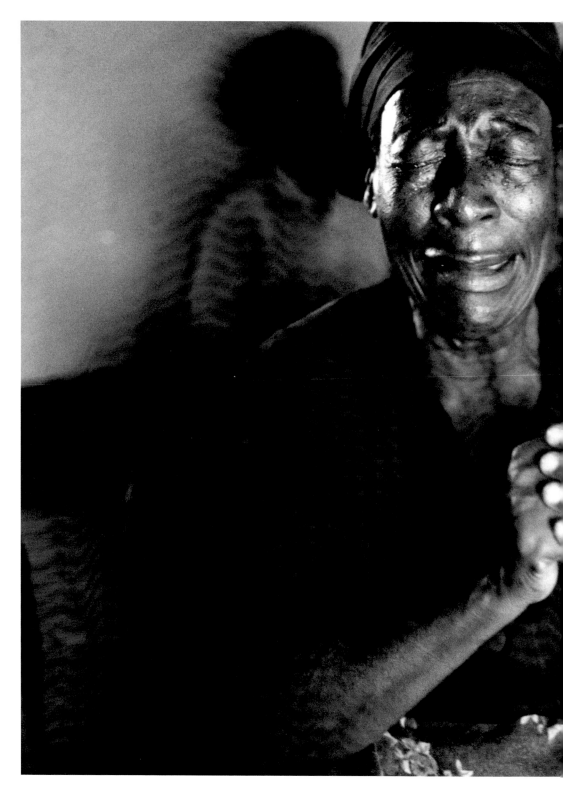

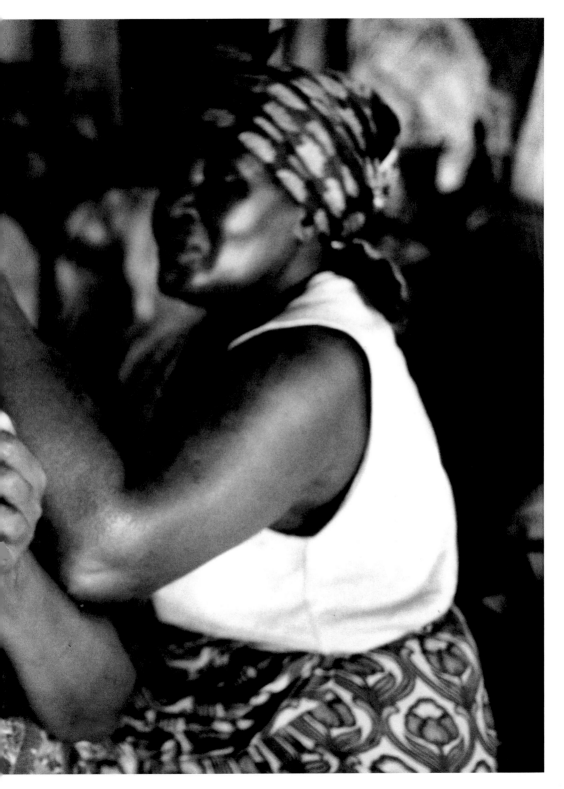

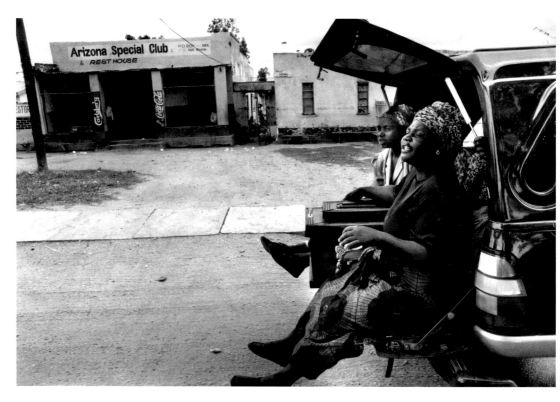

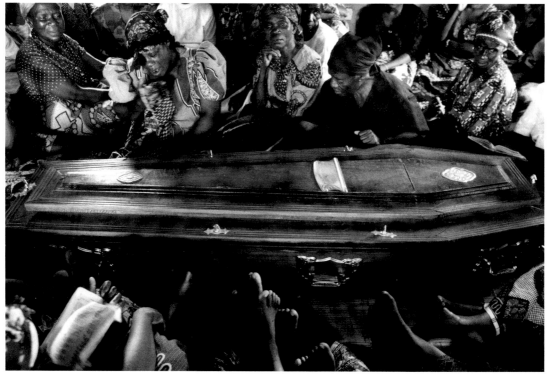

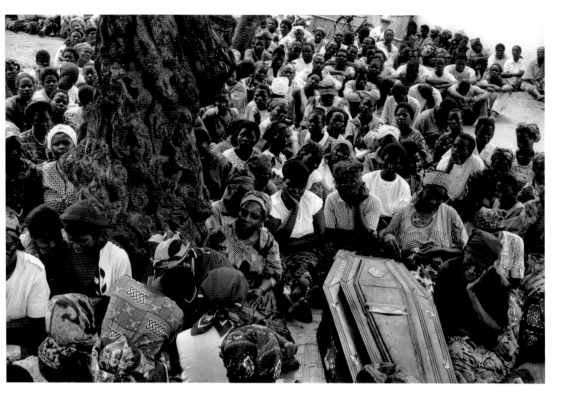

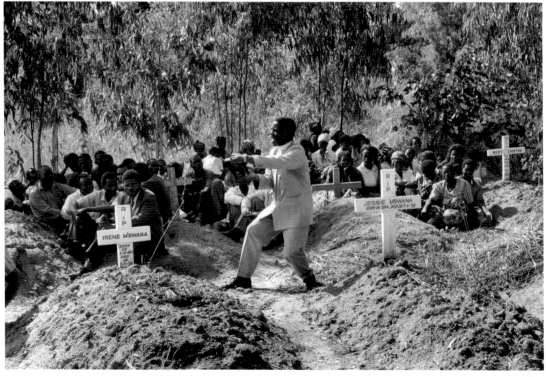

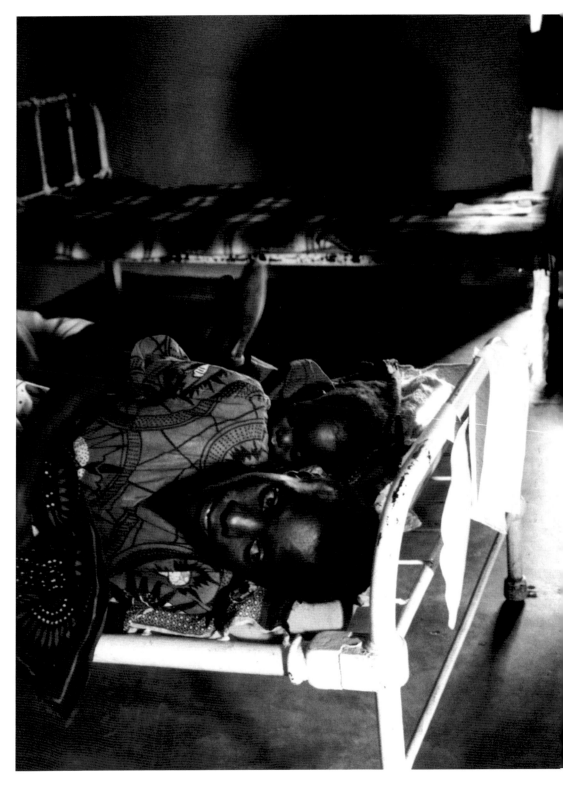

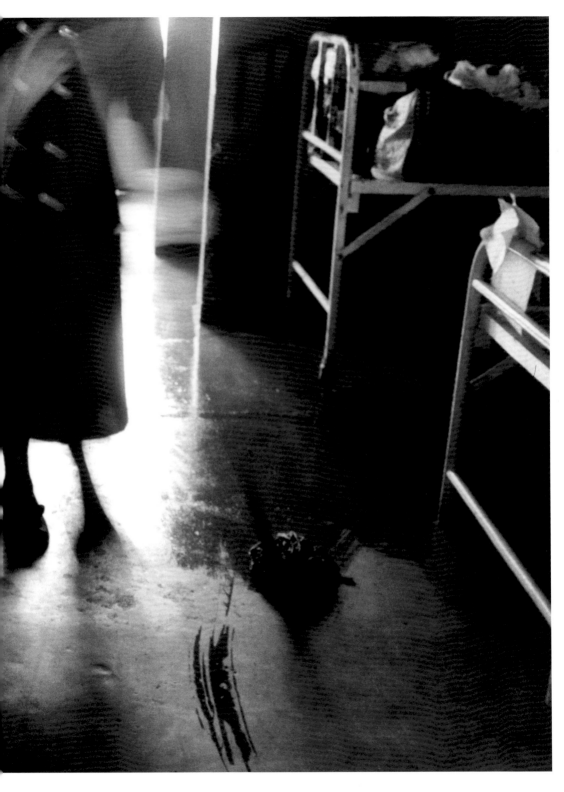

Mzokhona Malevu. Enseleni Township, South Africa

Mzokhona's family live in a squatter camp, having lost their home during political violence in 1992.

I have been ill for a long time, but it was only in 1998 that I discovered that I was positive. The first strength I got was from my counsellor, who asked me: who will I share this information with? At first I felt that I should tell only my mother, then I realised that I would be frustrated with this. I decided to share it with my community.

Last Sunday there was a candlelight service for those who have died and for those living with HIV or AIDS and for orphans and carers. Hundreds of people were there and I spoke there for the first time in public. I introduced myself to the people and told the youth that they must protect themselves. I got HIV by not taking care. People accepted me after I told them. People must get the knowledge, and I am not afraid to stand up in my community.

I know the day will come when God will take me, but I hope there will be a purpose in my death if it can help to educate my family and community. So I have decided that I want my funeral to be an AIDS education funeral where the message can be spread far and wide.

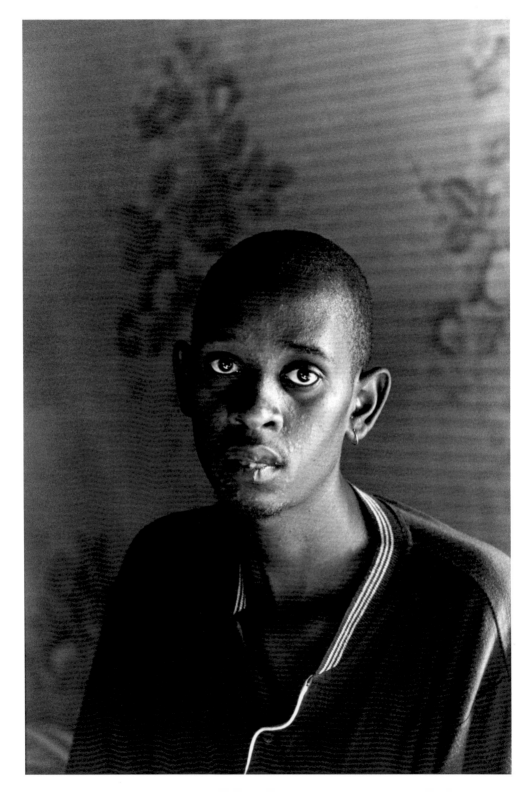

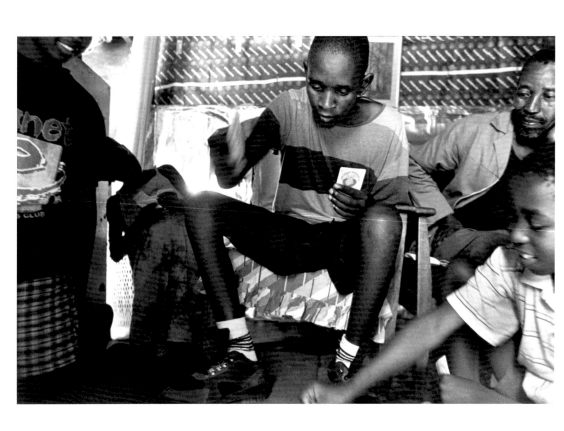

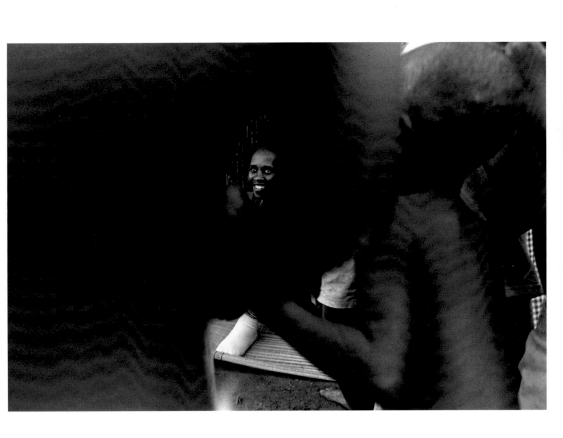

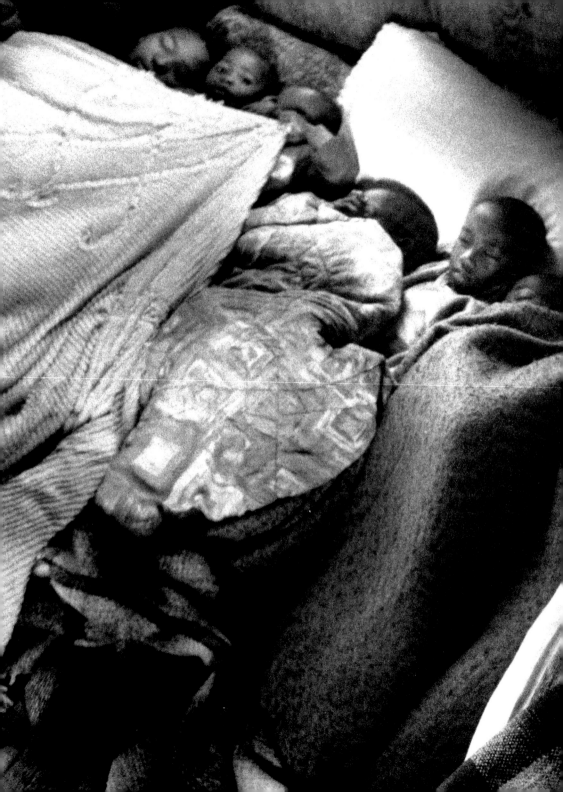

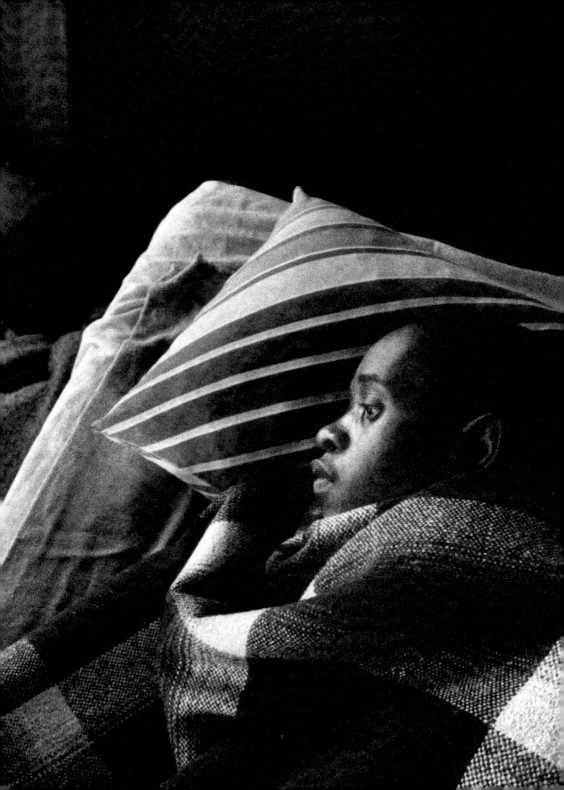

My father is employed sometimes doing piecework on construction sites and my mother works as a maid for whites in Richard's Bay. We live in two rooms here. There is my mother, father, their eight children and 11 grandchildren – 21 of us altogether. I sleep on the bed here in this room, with seven children sleeping on the floor next to me. Sometimes we do not have enough food to go round. My father usually bathes me early in the morning before he goes to work, but since recently we have to pay for water which he collects at the communal taps. It is 60 cents for a bucket. Now even some water for washing can be a problem.

I was given some drugs, which made me feel much better, but I cannot afford them now. I have heard that in overseas countries the government provides drugs and food free for people with AIDS, but here in South Africa there is nothing now. At the clinic they often say there is nothing they can do. You must go home. It is not fair. People overseas can get better from the good drugs they are given, while we in South Africa have to die.

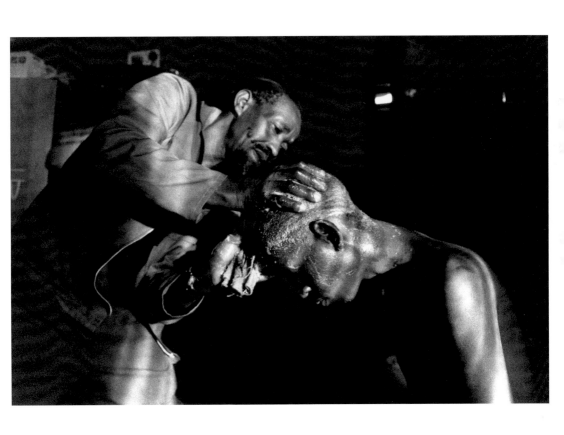

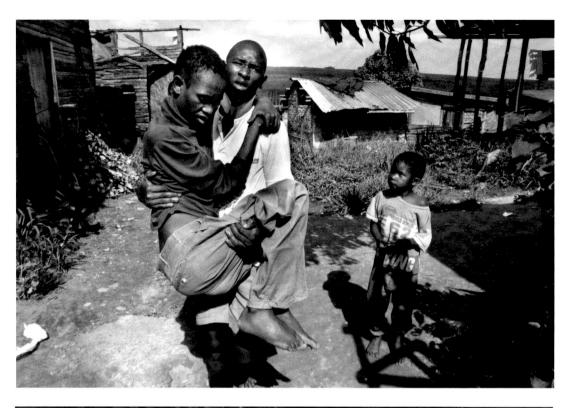
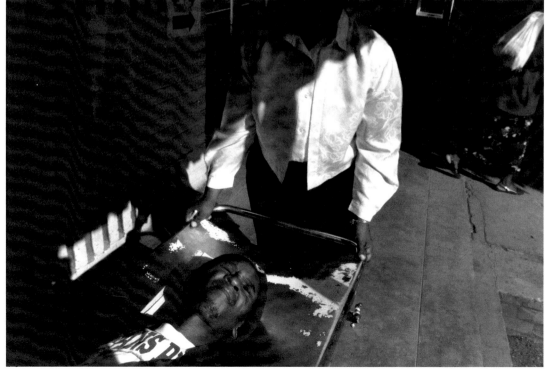

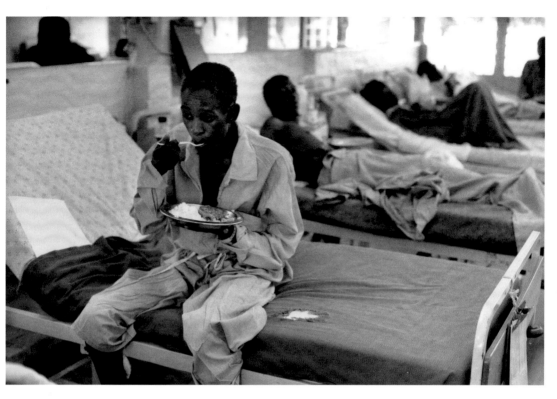

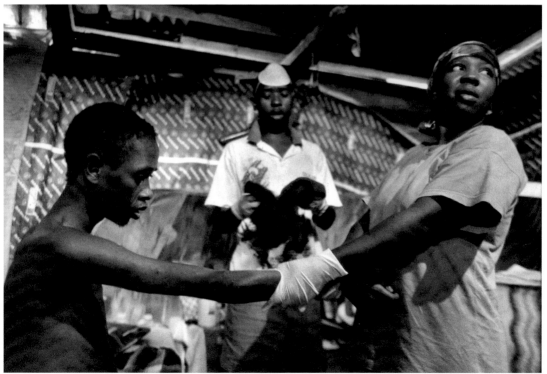

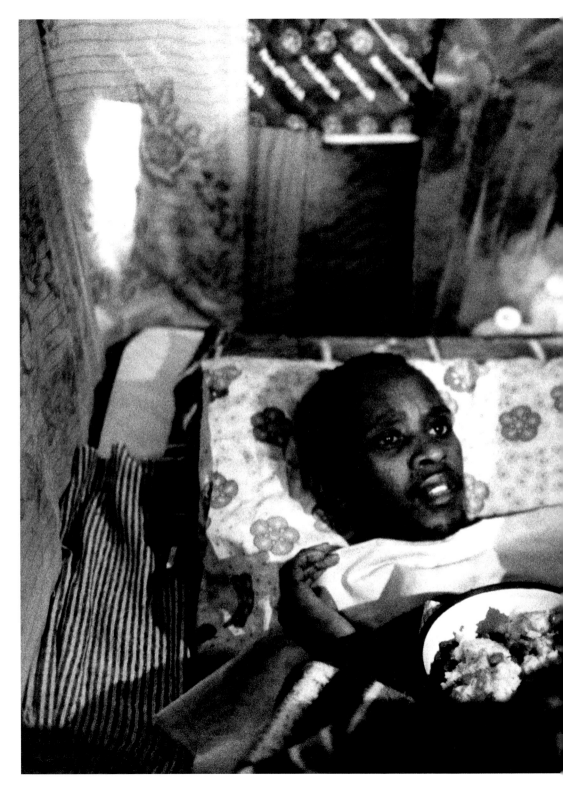

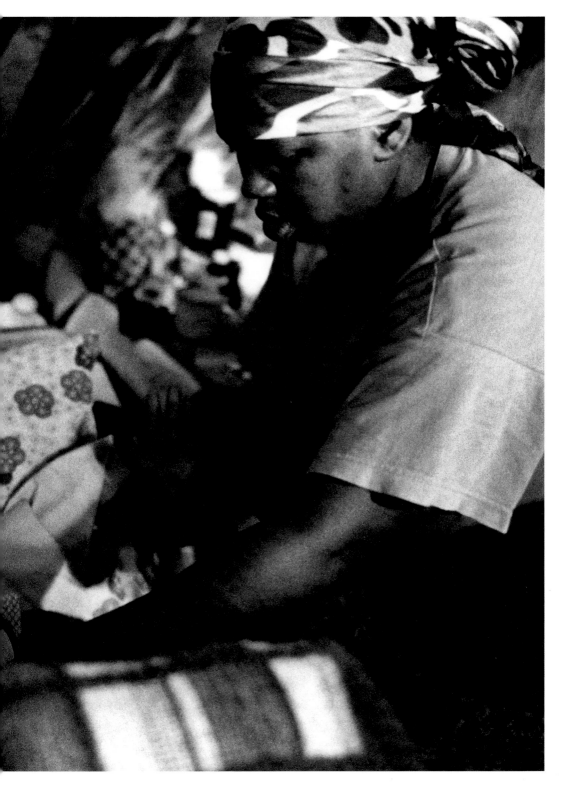

Mzokhona died on 2nd September 2000, aged 29. He died at home. His father came into his room in the morning and said he was full of sores and took him to the clinic. In the afternoon I decided to go to their house to check up on him. In the last months of his life he had gone blind, and then there was a time when he was shouting all the time. From Wednesday he stopped eating and he did not want to drink. His family had to force him. He knew he was about to die. On Saturday he called his sister and brother who had been the main ones taking care of him and said, heartfully, 'Thank you very very much.' When I saw him in his room, he just looked asleep to me, but his sister said that he is gone.

The body was collected that night at about eight pm. All the children and siblings and everyone living in that crowded house was very upset, everyone was crying and wailing. He used to speak at churches sometimes. We borrowed a wheelchair so he could get to church to speak. I saw him get sicker and sicker until the end. He was one of my favourite people.

NANCY KHUSWAYO, AIDS COUNSELLOR

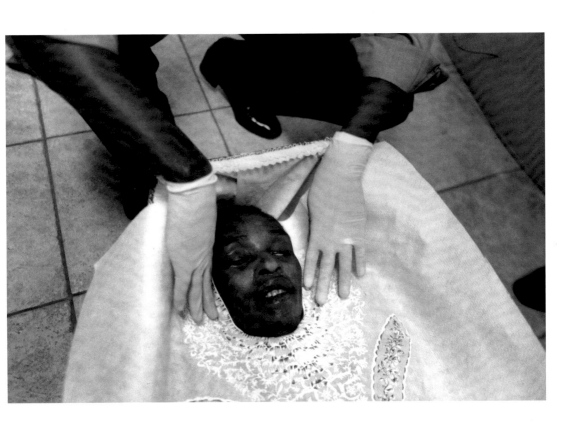

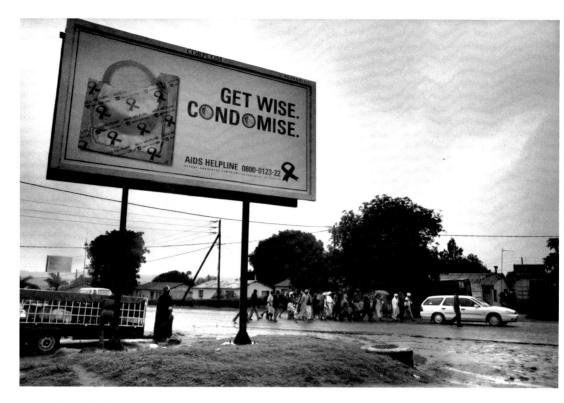
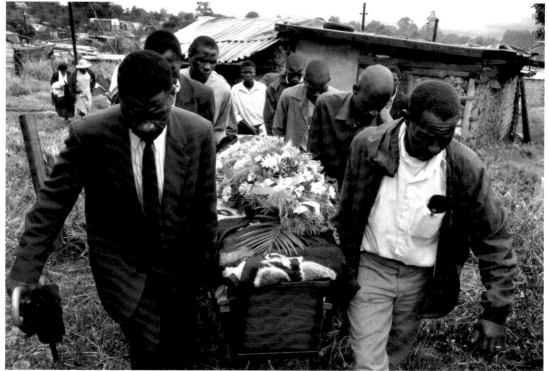

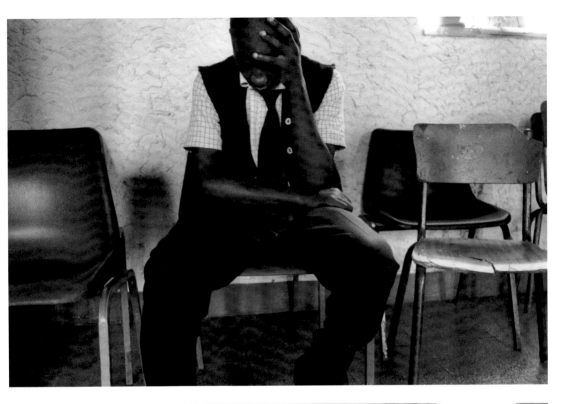
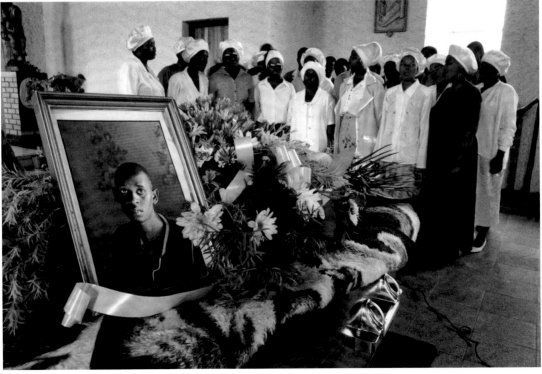

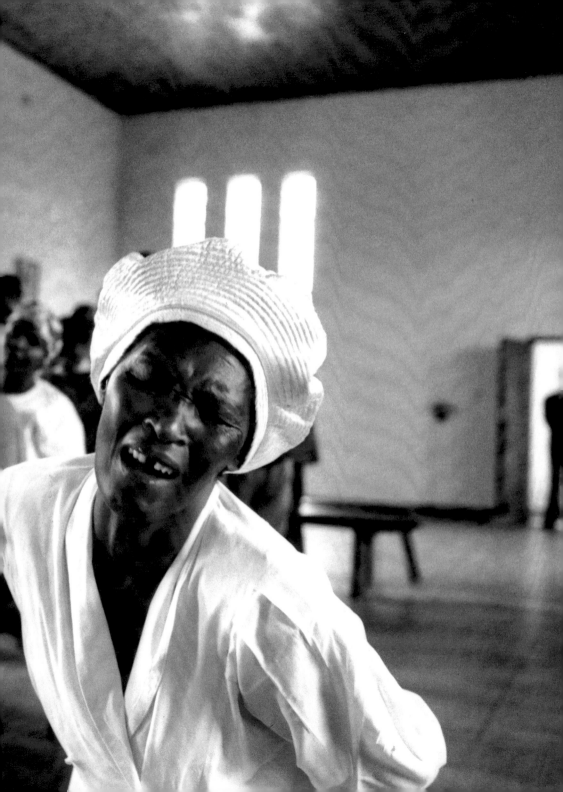

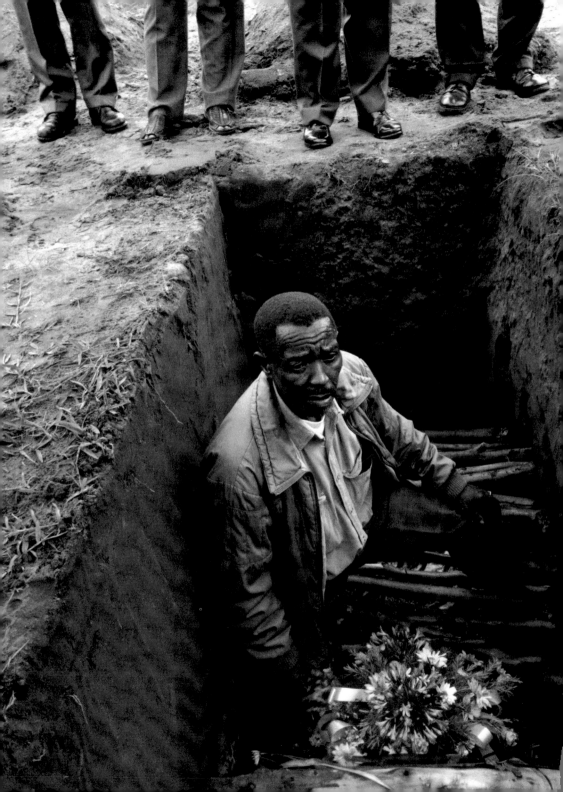

Sipho Gamede. Enseleni Township, South Africa

Sipho died in April 2000. He chose to have an AIDS education funeral.

He was a hero. He wanted people to know that AIDS kills. We have collected everyone together so people can learn that he is a hero for the fact that he decided to come out with his girlfriend so everyone can benefit. His family had the opportunity to learn. His family can get insight.

Ladies and gentlemen, this person loved his community and country. He requested that we bring you all here so you can learn and pass the message around, that this disease is like a snake, killing everybody; that even if you deny that you have AIDS, you still die. A person should know. This is important information I am giving you. Let us all go and test ourselves so that we can know.

SHUMI KHUMALO, YOUTH LEADER (FROM HIS FUNERAL SPEECH)

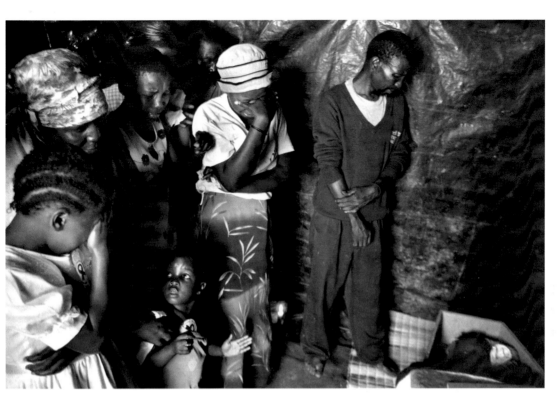

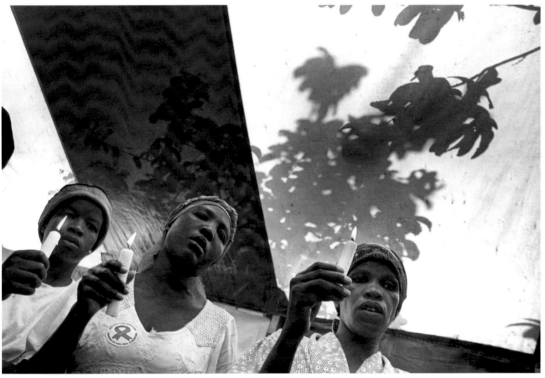

Funerals. Copperbelt, Zambia

For urban families in Zambia's mining region, as elsewhere, the cost of a funeral compounds the problems of losing a breadwinner.

The first worry when someone dies is money. If they die at home it is expensive to hire a van to take the body to the mortuary. Most of the people here cannot manage to pay so if it looks like their relative will die soon we help them get to the hospital so they can die there. You can get a car to take a person who is alive to the hospital and it will cost 5,000 Kwacha, but it costs 15,000 to transport a dead body to the mortuary. A body can remain at a home for a week because there is no money.

You know we don't count how many funerals we go to. Today in the cemeteries they are burying them as if it is a competition. Sometimes there can be more than six funerals happening at the same time. While the one funeral party is praying the other one is shovelling in the soil and the other is placing the coffin in the grave. Nearly every day there is a funeral for someone we know. In Ndola and Kitwe, mourners now have to dig their own graves. Because they have not been paid in four months, the gravediggers are on strike.

VIOLET MUKOSHA, NDOLA HOMECARE VOLUNTEER

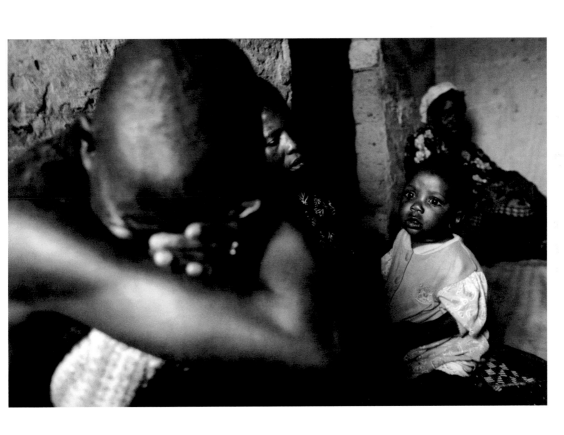

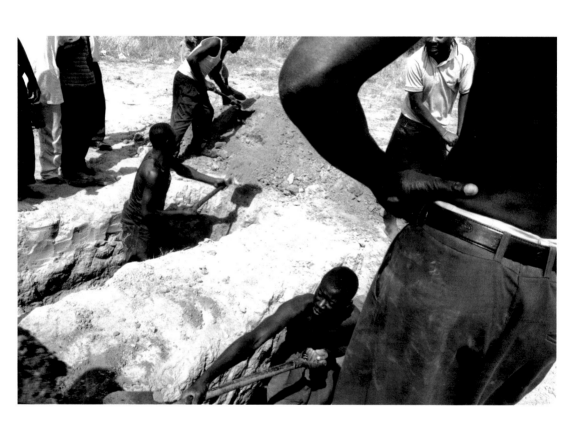

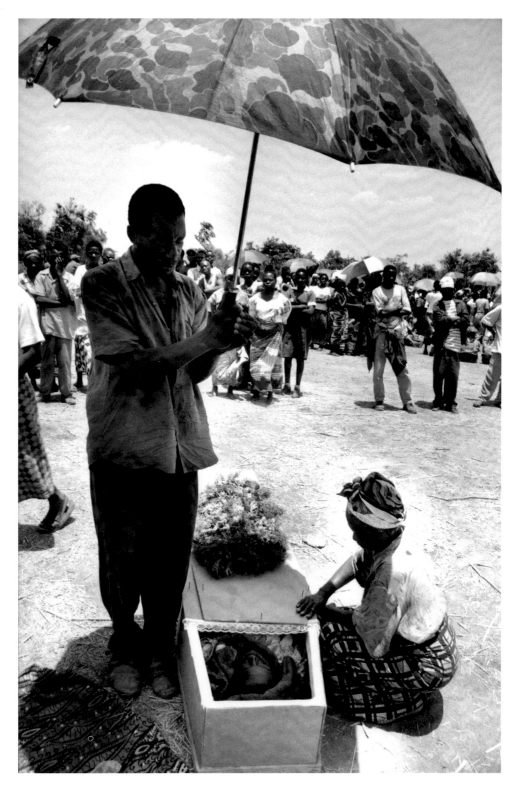

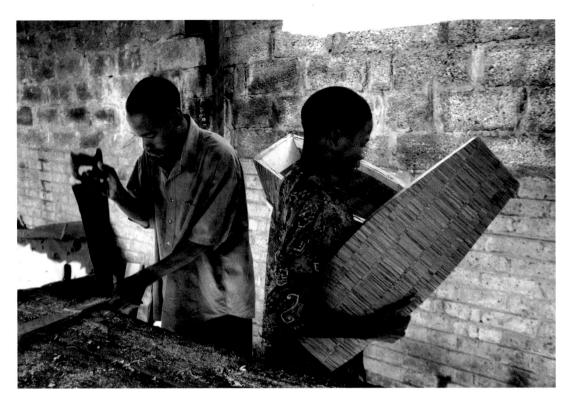

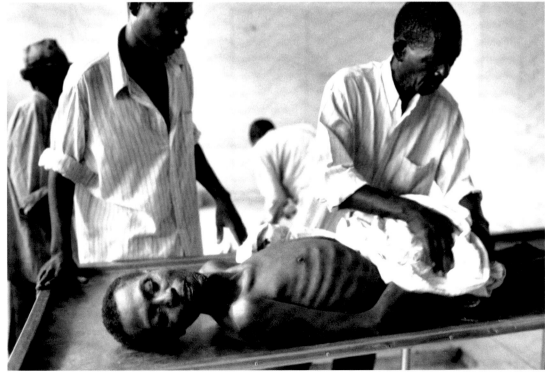

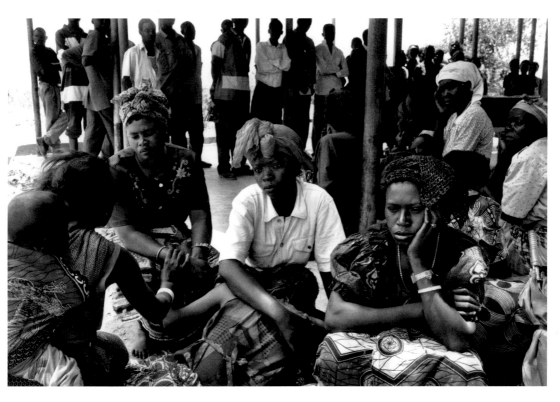
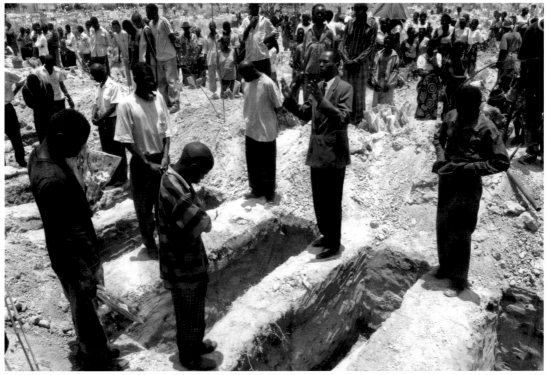

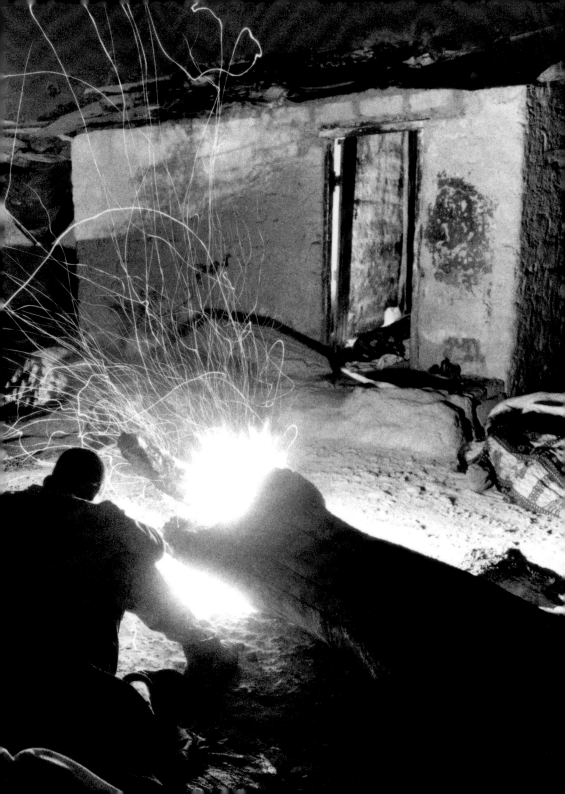

Homecare. Chikankata, Zambia

The Chikankata Hospital truck visits outlying villages as part of its homecare programme.

Here it is difficult to afford an aspirin. Our country spends $6.50 per head on health per year and we have more than 300,000 people living with AIDS so it is impossible to look after all of them in hospitals or hospices. So the AIDS team at our hospital started looking for another way. We decided to try to help people in their homes where we can visit, monitor them and teach their families how to care for them.

It works. Homecare uses the strength of the extended family, and fulfils the desire of most Zambians to die at home.We also found that neighbours were curious. We learned that the patient was an entry-point not just into the family, but into the community. That was when we started saying that care and prevention are linked.

We have now also trained care and prevention volunteers in 16 villages. Our 'community counselling' philosophy challenges people to look at their customs and personal behaviour. We know of many cases where this has led to change.

DAPHETONE SIAME, DIRECTOR OF AIDS MANAGEMENT

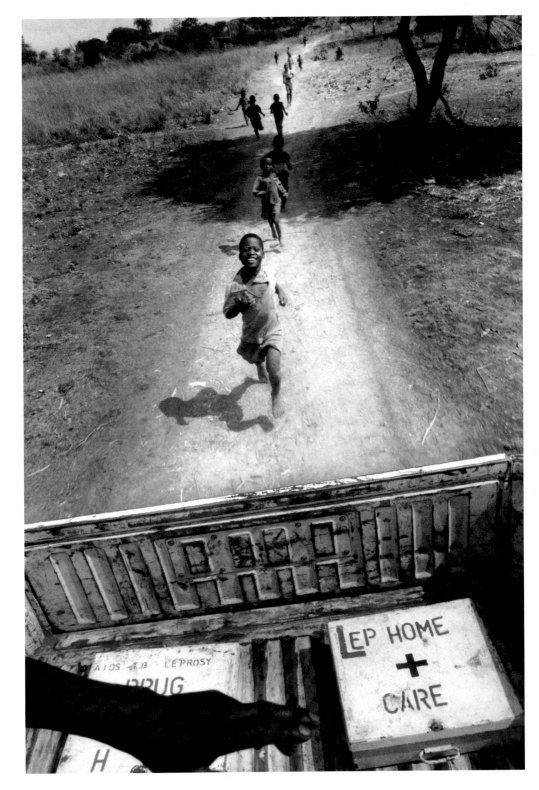

Homecare. Ndola, Zambia

Volunteers are key to the Ndola homecare programme.

When you are already poor and you get sick, it is much worse. In our compound many people who have the disease die quickly because of hunger and lack of medicine. Poverty and this disease, they work hand in hand, especially in a family where the breadwinner is sick. When they are sick on Monday, the family has no food on Tuesday. If the breadwinner is sick it means the whole family is sick.

As volunteers we try to take care of our patients in the ways that they need. We have the job of helping them to take their medication, particularly for TB where it is very important that the drugs are taken every day. Sometimes when the parents are not able to we have to do everything – wash the children, sweep the floor, wash the plates, wash the clothes and cook porridge for the family. When they are very ill all we can offer is our company and support. If they are believers we will pray with them.

VIOLET MWINUKA, HOMECARE VOLUNTEER

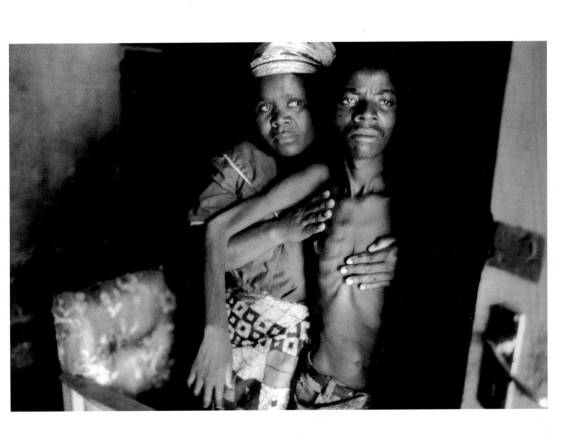

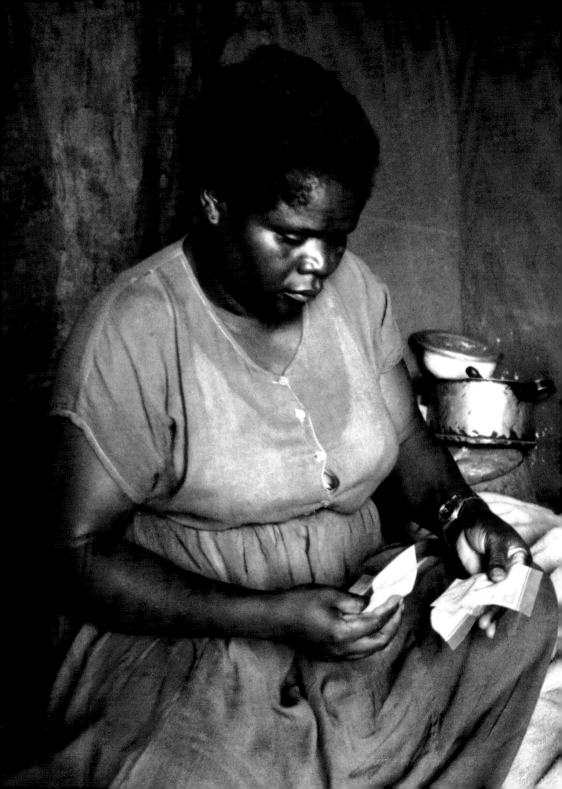

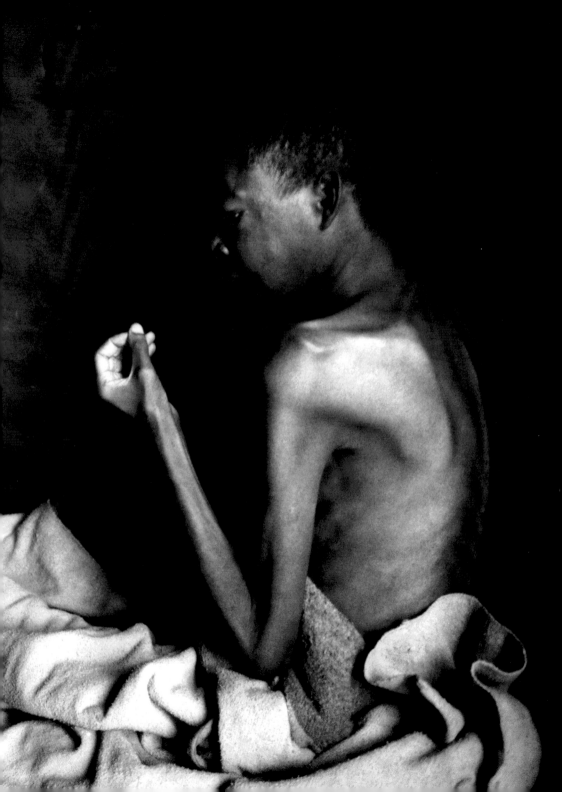

My work involves visiting patients in their homes, giving appropriate medication and advising patients and their families on measures they can take to maintain or improve their level of health. I visit with voluntary homecare workers who live in the local communities and who are able to make regular checks on patients' progress. They can identify who has the most pressing needs.

We know that HIV-infected mothers can pass the virus to their babies via breastfeeding, but in these compounds people are so poor that it is impossible for them to provide a well balanced diet for their babies without breastmilk. If they are not breastfed they cannot fight infection properly and can die from malnutrition or diarrhoea, or other infections like measles and malaria.

AIDS is affecting our community on every level. Most of our clients are not able to work so the economy is being affected. We are going towards the season of planting, but the chronically ill patients cannot go to the fields or work in industry. Poverty is the result.

JESSIE KAMOLONDO, SENIOR NURSE

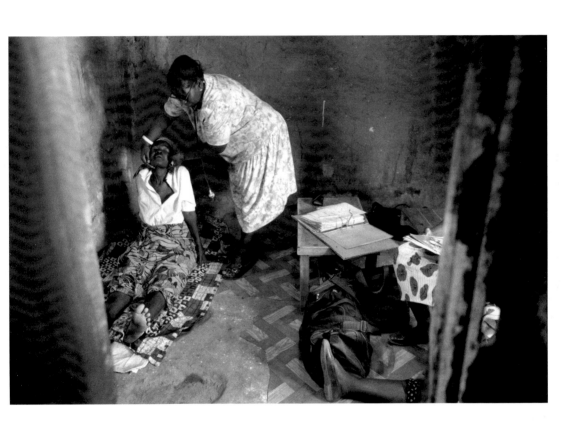

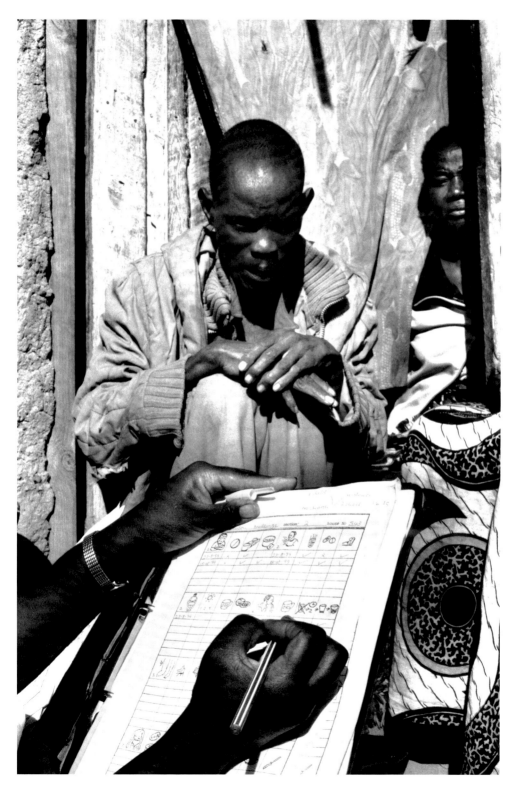

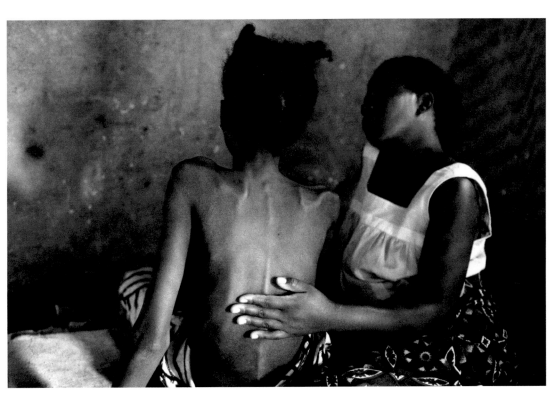

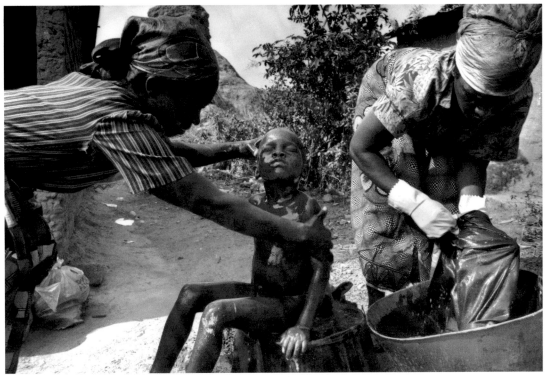

Janet is the main patient that I am taking care of now. She lives close to my home but I did not know her before she was ill. I clean her house, I wash her, I help her taking medicines and I cook for her and feed her. Janet is alone – there are no family members to take care of her. Since she is now very sick I am trying to contact her relatives who could maybe take her to their place or send someone to take care of her here. The problem is at night, because she is alone. There is nobody to give her water to drink or to look after her.

EDWICE ZULU, HOMECARE VOLUNTEER

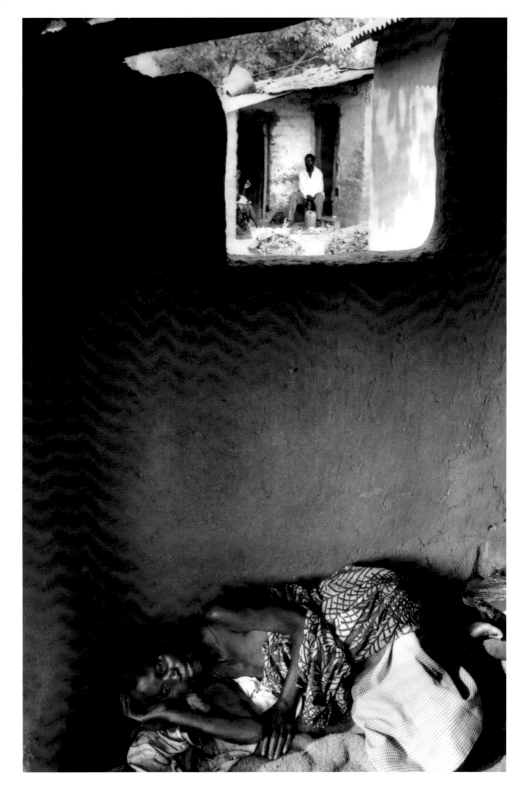

Homecare. Bukoba, Tanzania

A medical assistant visits Faustina Nyauga at home, providing care and helping the family work out what is best for Faustina's children.

We go by foot or bicycle to see how our patients are. With the stigma it would be a problem if we went by car. People would know it was the AIDS car.

With most patients you can see the children are not going to school, the children are not getting enough food. The mother is sick, the children are sick, and who is helping them? There is nobody else.

It's the same problem everywhere: poverty. We are trying our best but this disease is very discouraging. It can be too much to witness suffering every day. But then we see that the patients need our help and we are happy to help them and they are happy because we talk to them; we joke with them and we comfort them. The patient feels 'I am still a human being' when I touch them.

AMRI BYARUGABA, MEDICAL ASSISTANT

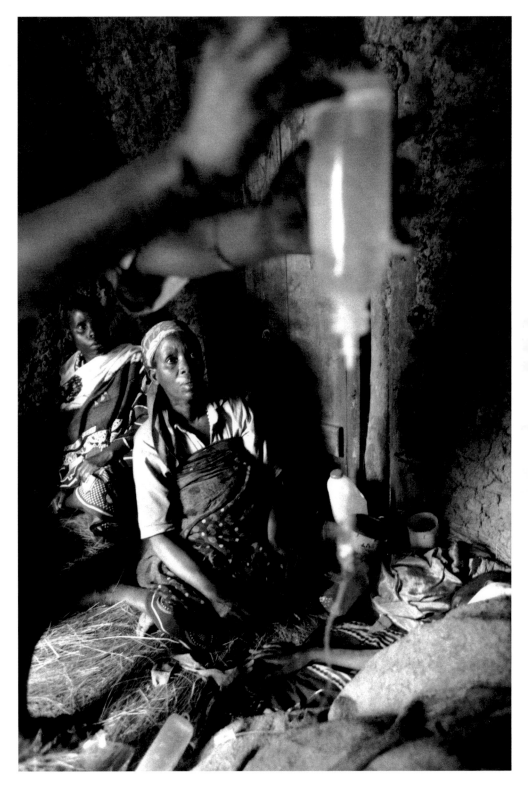

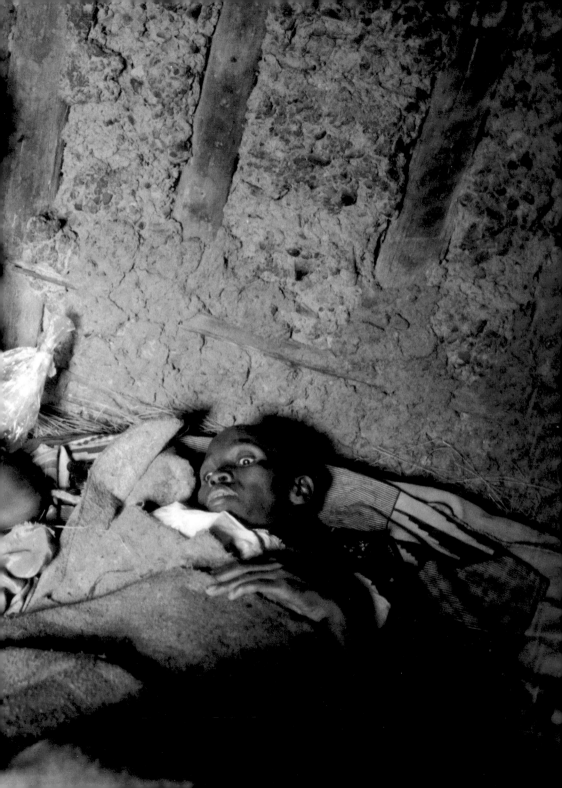

Orphans. Copperbelt, Zambia

The extended family is at breaking point as a result of the number of AIDS deaths.

I was born in 1934. I had nine children. All my children are dead now but for one. I am suffering here. I'm keeping eight orphan grandchildren – Cecilia, Cholo, Dyanis, Joseph, Jennifer, Douglas, Lydia and Grace. And my blind husband. I am not happy. This disease is destroying so many. The children I am looking after – their father and mother died of AIDS. Sometimes I am so angry. I am suffering here trying to take care of so many with no income. These children don't have clothes. I don't have a bed. I don't have blankets, just empty sacks. There is no floor in our hut. We sleep in the dust. I can only give each one a small amount of food. If they are not satisfied they start fighting and I start crying. My one remaining daughter is often ill and I think that she has HIV. Thinking about her makes me cry. I am getting old and I can no longer grow food for myself. Anytime I can die. Who is going to keep my grandchildren? How will they survive once I am gone?

ANNA MULENGA

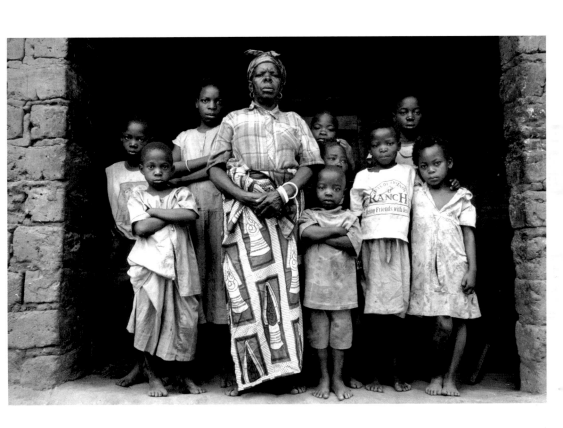

My name is Sola Chasala. I am ten years old and I live with my older sister Beatrice, as my mother and father are both dead. My mother died in December. Every day I wash plates, sweep the house and go to school.

I would like to live together with all my brothers and sisters but there is not enough food for us all to live in the same place. Sometimes I see them all at the weekend but I would like to see them more.

I like living here. I like the houses and the trees and I like to see the aeroplanes flying overhead. I think that maybe the president is inside. If I was the president I would reduce the price of mealie meal and charcoal so that everybody can eat.

SOLA CHASALA

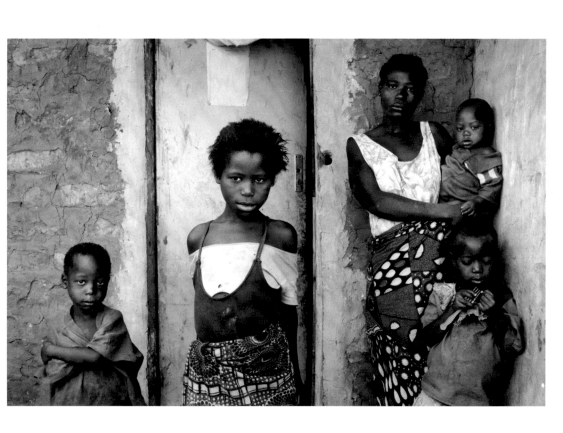

My name is Janet Mbulo and I am 20 years old. Since our father died on the 17th of November 1997 things have been very difficult for us. He was the one earning an income. Our mother then died in 1998. Even from long before then because our parents were ill the older children had to take care of the younger ones. We have all managed to stay together in our family home in Kwacha Compound but now we struggle to survive. We used to bake scones to sell at the market but we could not continue as our electricity was disconnected after we did not pay the bill. We make a bit of money by making doormats to sell and we are helped by an organisation which gives us some maize meal every month and pays the school fees for Joyson, Joshua and David. Monica, Musonda and Christopher stay with me at home.

JANET MBULO

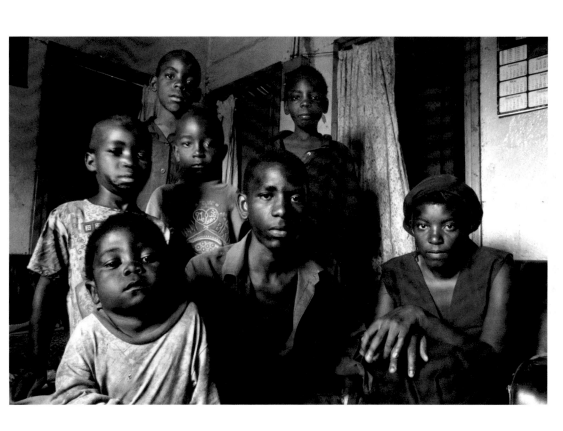

This school is free and I am a volunteer teacher. The pupils come here because they can't manage to pay the fees for the government schools. They need to pay fees and pay for shoes and uniforms, whereas we do not demand them. We just ask for a minimum contribution of 1,000 Kwacha per month. Some can't afford that but we still let them come to the school. It is for the community, and if it was not here, many children would get no education at all.

There are 87 children in my class of whom 47 are orphans. We teach the children about AIDS so that they can try to protect themselves when they get older.

PRISCA MWANSA, IPSUKILO COMMUNITY SCHOOL

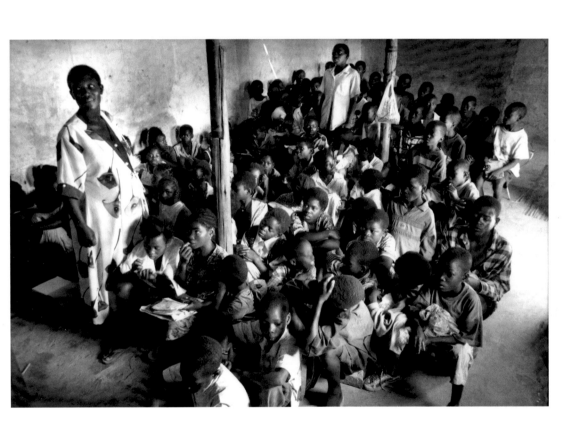

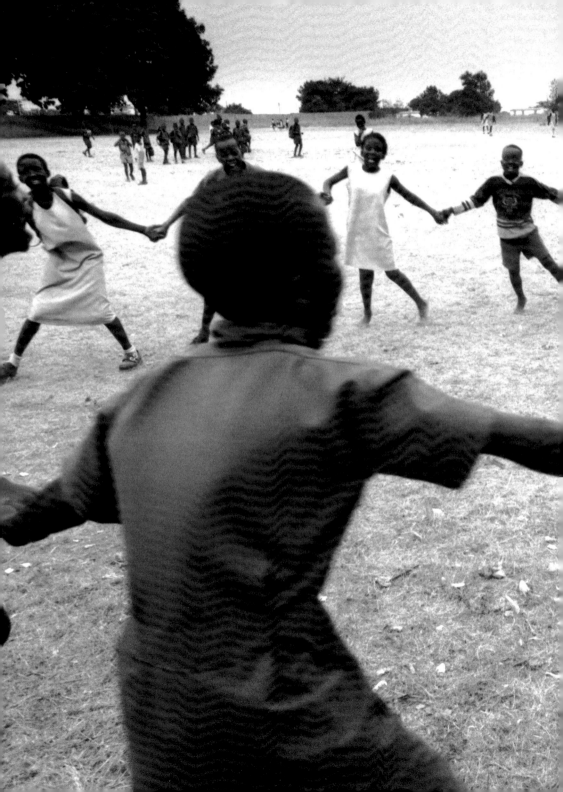

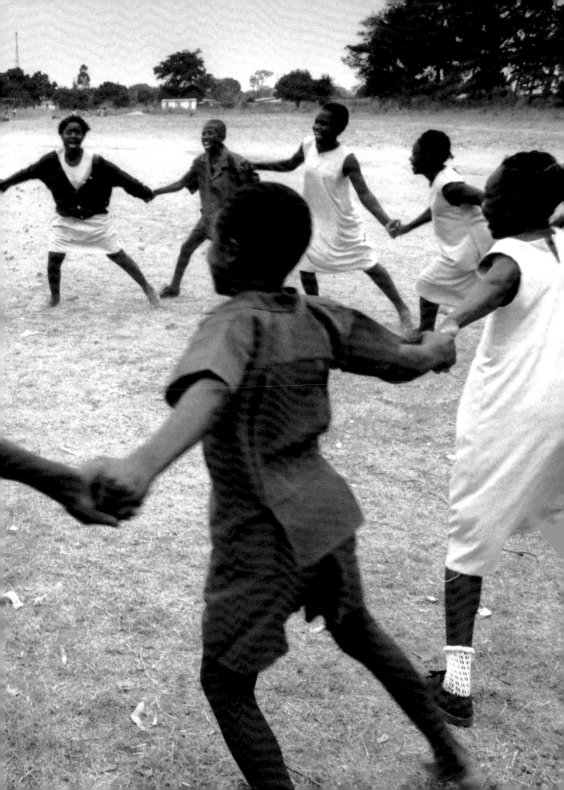

Mwila family. Chilonga, Zambia

Joanna (7), Joseph (9) and Aaron (2) became orphans in 1995.

When my six grandchildren came to live with me
I felt bad, but then I accepted I was the only one
who could look after them. I've had no assistance
from other relatives, only from the convent and
the Anti-AIDS unit. I'm 72 years old and it is very
difficult to take care of them properly so sometimes
I have to beg from neighbours. I have started
tilling to grow some beans, ground nuts and maize
for us to eat. I've about a hectare of land. Nobody
helps me with the farming, except the children.

The hardest thing is to feed them. I watch them
playing their favourite game which is to pretend
to cook and eat. I don't know what will happen to
them as they grow up but I hope it's only good news.
ALBINA MWILA

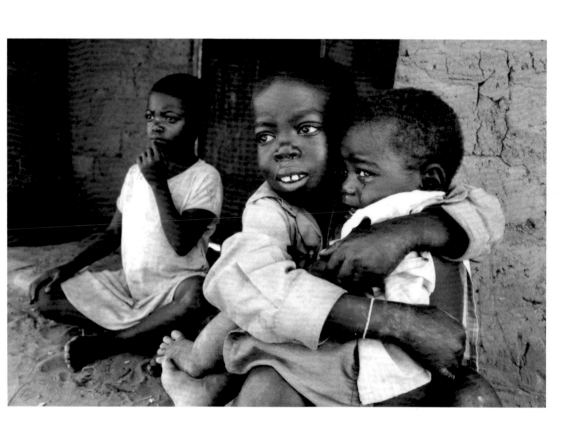

Gatsi family. Chinhoyi, Zimbabwe

Melody (7), Russie (12), Joshua (11), Bianca (10) and Esnath (13) have lost both parents. They look after themselves while their older sister Grace (17) works as a domestic servant in Harare.

We sometimes go for three days without any food. Sometimes we do not go to school because the other children will be teasing us since our uniforms are usually dirty and sometimes we are just too hungry to do school work. I am 12 years old and doing grade 6. We get some money from Grace but it is not enough. We usually go and work in people's homes in exchange for food and clothes.

JOSHUA GATSI

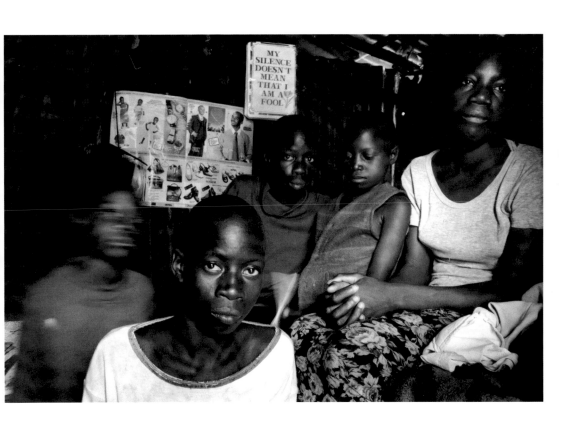

Thembeka Sibiya. Enseleni Township, South Africa

Thembeka (11) looks after her younger brother Sandile and
sisters Lihle and Quinn.

When my parents died we stayed in the room by
ourselves. We were given food by the neighbours.
I carried messages for people to earn some
money. In times when there was no food my
sisters would beg leftovers from our neighbours'
pots. Sometimes the wife of the reverend would
bring us food, and now we have moved into her
house. Before this we were living by ourselves for
two years. If I have one wish it is to be able to
study to be a social worker so that I can help other
children the same way that I have been helped.

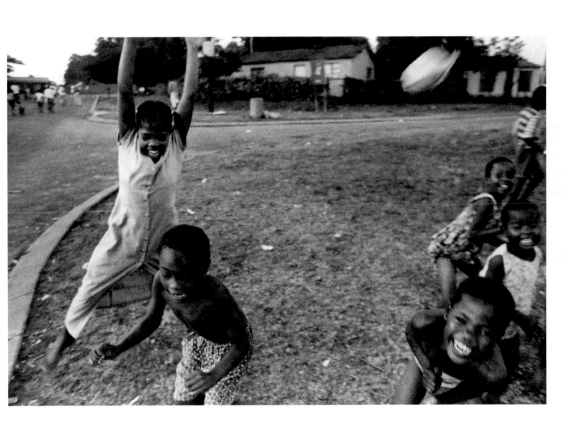

Peter Mguni. Enseleni Township, South Africa

Peter (8) is ill with AIDS and cared for by his great-aunt Emily Mguni.

All Peter's family is dead. He is the only one left.
His grandfather is the brother of my father. When
his parents died he was left alone. I nursed his
mother until she died because no-one else was
willing to look after her. I have a family of 10 to
take care of. I only have a small pension. I try to
take him to the clinic because he is covered in
sores, but it is a long way to go and expensive to
get taxis. Sometimes he cannot walk and I have to
carry him on my back.

EMILY MGUNI

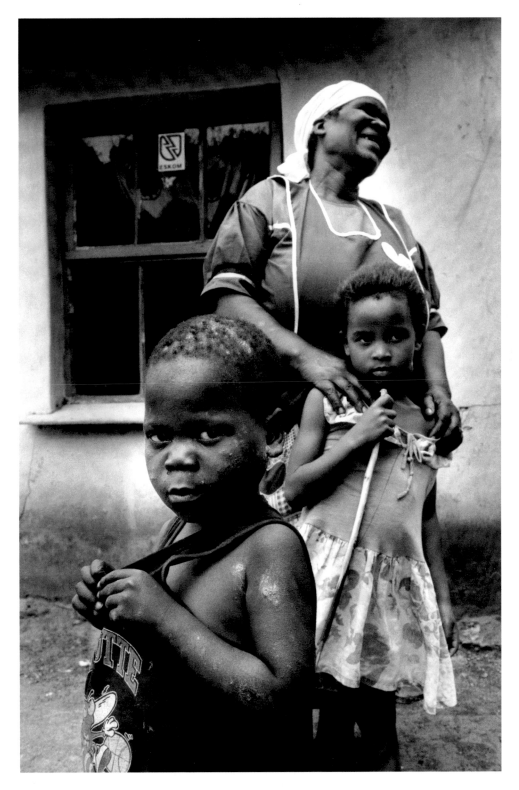

Placidia Karugendo. Bukoba, Tanzania

Placidia (13) suffers from an AIDS-related skin infection.

When I am doing my job visiting and caring for patients in their homes, some people really move me. Placidia is one. She has a fungal skin infection covering most of her body yet she has such bright eyes and always has so much to tell me. She is 13 years old. I think that she is very intelligent.

We believe that she was infected with HIV when she received a blood transfusion from her father to treat a case of malarial anaemia that she had when she was a child. Her father died last year and her mother is now very ill so they are extremely poor. Placidia has been sick on and off over the last year. She has done very well at school over the last year despite being so ill and having to miss so much school. When we visited her last time she was very proud to show me her report card. She had come top of her class.

AMRI BYARUGABA, MEDICAL ASSISTANT

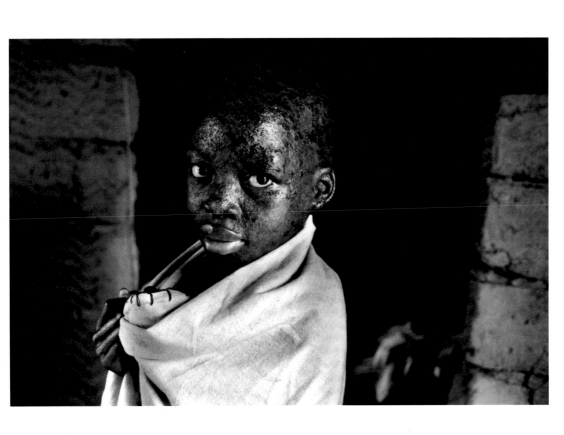

Children's ward. Ngwelezane, South Africa

Half of the children's ward admissions at Ngwelezane Hospital are for HIV-related illnesses.

This disease has dramatically increased our workload.

It is not just the children but also their relatives who need help, but we do not have the resources to help the parents. We see many teenage mothers with psychological trauma when they lose their babies and discover that they have HIV at the same time. They are not prepared for that. We also see how AIDS often affects the family relationship because often one of the parents, usually the father, does not accept that the child is infected with HIV. They then blame the other parent for the infection. Sometimes this results in violence or separation, or both.

I have three children of my own, and as a mother it gives me a lot of pain to see so many babies and children who are dying. Sometimes as nurses we feel traumatised by seeing so much suffering but we can't allow that to stop us from doing our work. We have to go on with our lives serving the community and providing the care that is expected from us.

JUNE MNGADI, CHIEF NURSE, PEDIATRIC RESUSCITATION UNIT

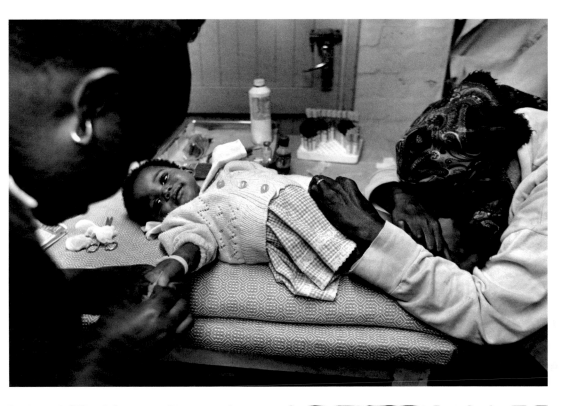
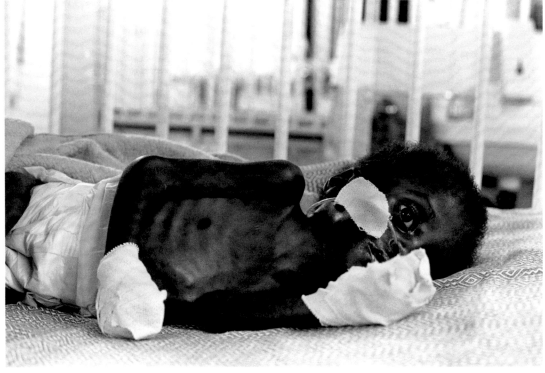

Nazareth House. Cape Town, South Africa

Nazareth House is a children's home taking care of abandoned children with HIV or AIDS.

This picture shows Josaphat who came to us in the last stages of AIDS after being abandoned in hospital. Here he is enjoying a massage from a volunteer aromatherapist. Unfortunately she had to wear gloves as his body was covered in a fungal infection. In general we believe in giving our children as much physical contact as possible without the use of gloves. We concentrate on helping children live as normal, happy and healthy a childhood as possible. For most of our children, this is the only home they will ever know so we must make sure that this is a real home full of love and joy.

When the time comes for a child to pass away we strongly believe in letting them die with dignity in familiar surroundings and not in a hospital. It is important that the caregiver with whom the child has the strongest bond is there with the child to hold him or her during their last moments.

SISTER MARGARET, HOUSEMOTHER

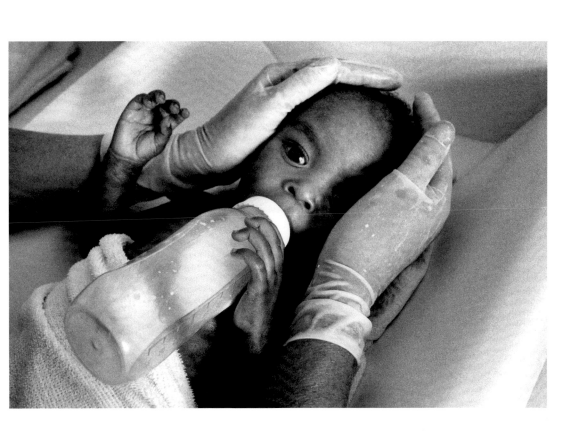

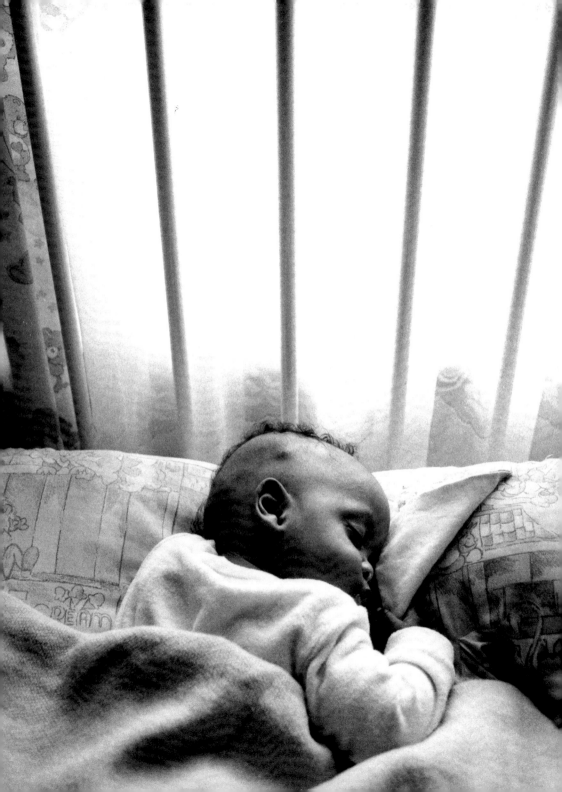

Ford assembly plant. Silverton, South Africa

The National Union of Metal Workers and the factory management at the Ford plant take an active role in AIDS education and prevention.

Up to the end of 1998 this company, like many companies in South Africa, was still in the process of speculating about the reality of AIDS. We moved into action in November 1998 when the entire plant was closed for an afternoon for awareness training. 150 cars were not made that day. Since April 1999 we started dispensing free condoms. At first it was limited to the clinic, and 700 condoms were distributed each month. Then we extended it to the factory gate and the toilet blocks. Now we distribute 17,000 condoms a month.

JOHAN STRYDOM, HUMAN RESOURCE MANAGER

I am proud that in our company the union and management have come to a partnership and we have a good policy. I have been a shop steward for seven years. I often address the workers in our factory during union general meetings about AIDS. We have begun with employees in the plant but it is important that we make an impact in the community as well. We must spread the word in all ways, through the churches, on taxis, buses, even at funerals. Our plan is to try involve everybody.

JIMMY KHUMALO, NATIONAL UNION OF METALWORKERS (NUMSA)

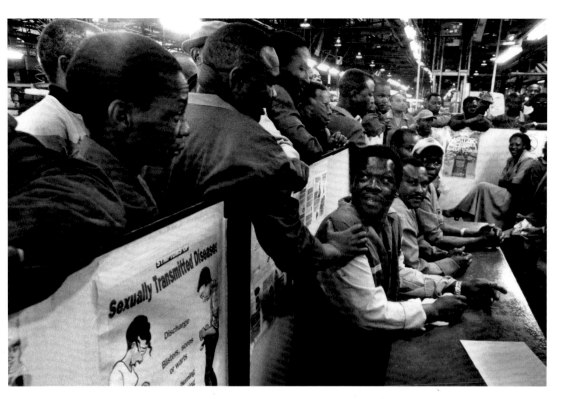
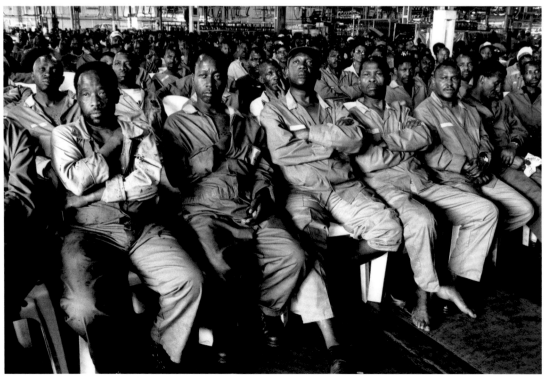

Lonmin Mine. Rustenberg, South Africa

Lonmin is a platinum mine where, according to a survey in 2000, 24% of the miners are HIV positive.

I am from a small village called Tabase near Umtata in the Transkei. I have been working at Lonmin Mine for nine years. I supervise the drill machines and drains and ventilation. I work 12 hours underground every day to earn as much as I can. I have a large family who I am responsible for. I earn 2,200 Rand per month and I send back at least 1,000 Rand to my family. I stay here in the hostel where 12 men share a room. At this mine there are some rooms where a man's wife is allowed to come to stay for one month a year, but it is difficult for my wife to do that because she needs to be at home to take care of my family.

At the mine they have been telling us about condoms. Many of the men go outside to look at other women. Our union has been telling us about the dangers of AIDS. I do not want to use a condom. The men say that if they have sex, it must be 'flesh to flesh'. I would rather stay here in the hostel and not go out. I want to protect myself so I can support and satisfy my family.

NTOBEKO NGWENZE, TEAM SUPERVISOR

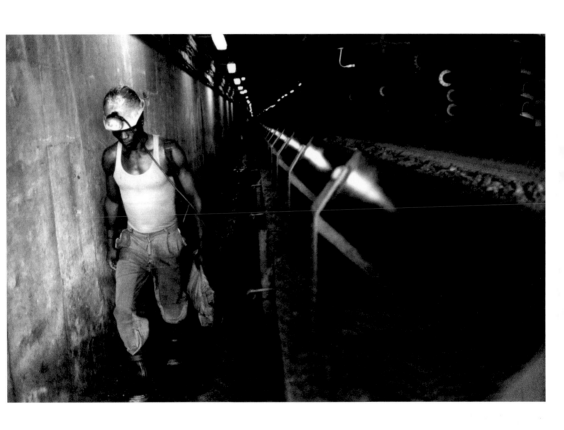

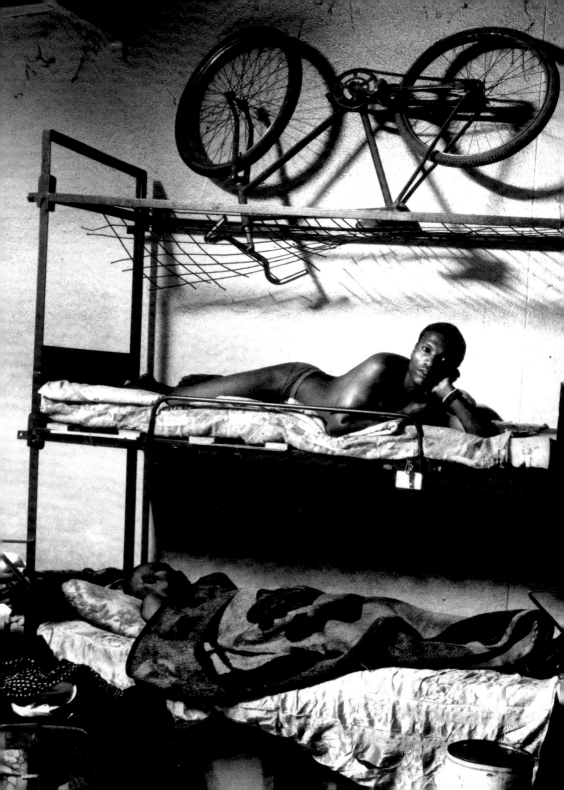

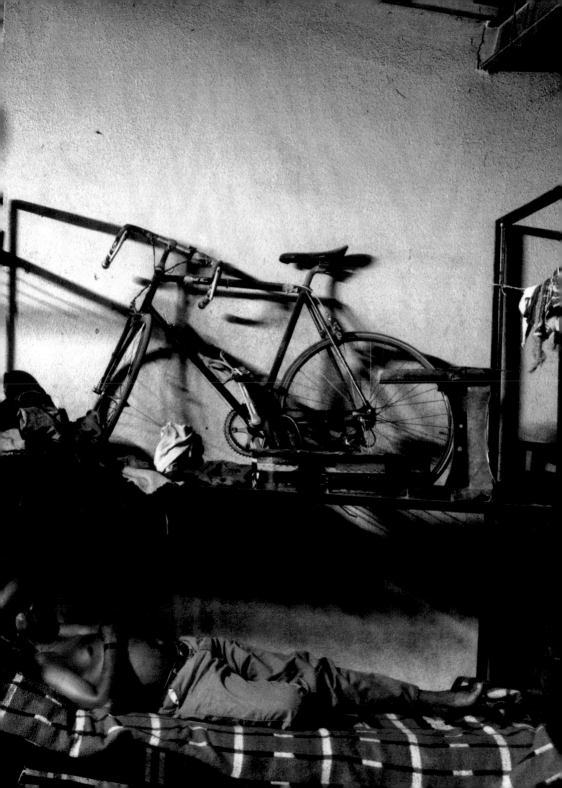

I am 31 years old. I have come here to the mine to do sex work to support my family and my children back in Transkei. Nobody in my family is employed so it is only me earning any money. In September last year I met Busi and she told me about condoms and HIV. She invited me to join the peer educators group. In the project I teach people about sexually transmitted diseases and HIV and I show the people how to use condoms. I teach both the mineworkers who come to the shebeens around here and the other girls who sell sex.

It is difficult for many of the girls to get the men to use condoms. Some will only pay half – they say 'I do not sleep with you, I sleep with the plastic.' Because now I am HIV positive, if a man wants sex without a condom I say 'No'. Sometimes the men don't believe me when I tell them. They say I look too beautiful and healthy. I take good care of myself.

NOSIPO MPETSHWA, PEER EDUCATOR

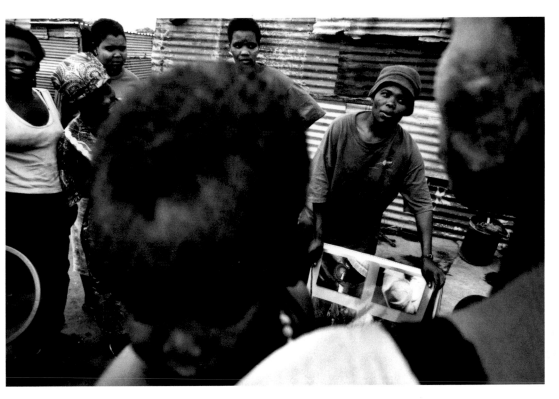

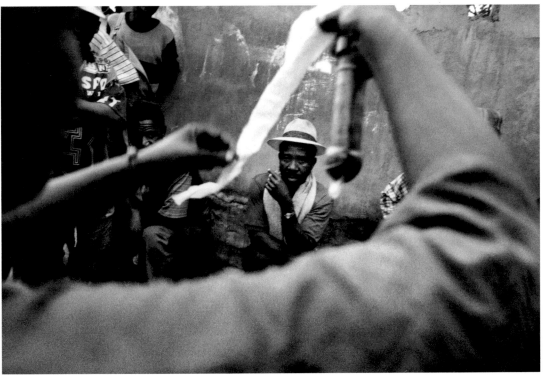

Rose Kamuriwo. Chinhoyi, Zimbabwe

Rose lives openly with AIDS and participates in a drama group
educating sex workers and their clients about HIV and AIDS.

Janet and I were sex workers for more than 15
years. We never got further education and we
never got decent jobs. There was no other way
for us to earn a living. When Janet got ill, her
landlord threw her out and now she lives at my
house. My cousin Fungai's mother died of AIDS
and then Fungai also came to live with us. My
boyfriend Clemence lives with us too, and he
also has AIDS. Janet cannot walk. My 4-year-old
daughter Eva is also sick. Fungai looks after us all.

I enjoy participating in peer education pro-
grammes mainly due to the fact that I receive
emotional support from my peers. I also receive
a small allowance at the end of every month, but
most of all I want to educate people, especially
young people, on prevention. I don't want to see
the number of infected people increasing. I want
to give hope to the infected and help them live
positively. In many instances, people point fingers
at me saying that I have AIDS but that does not
deter me from my work.

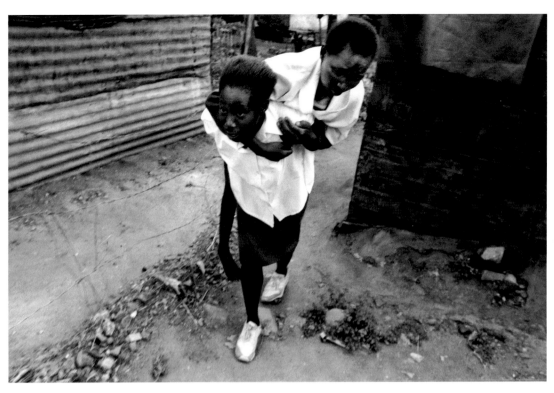

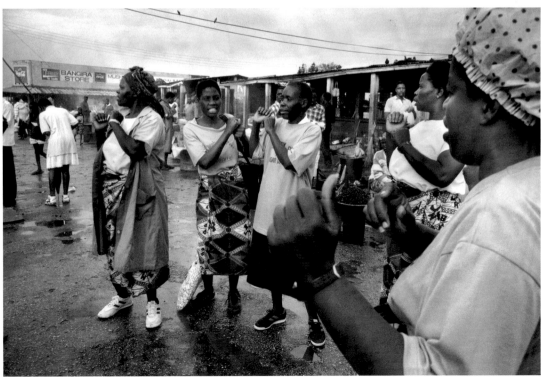

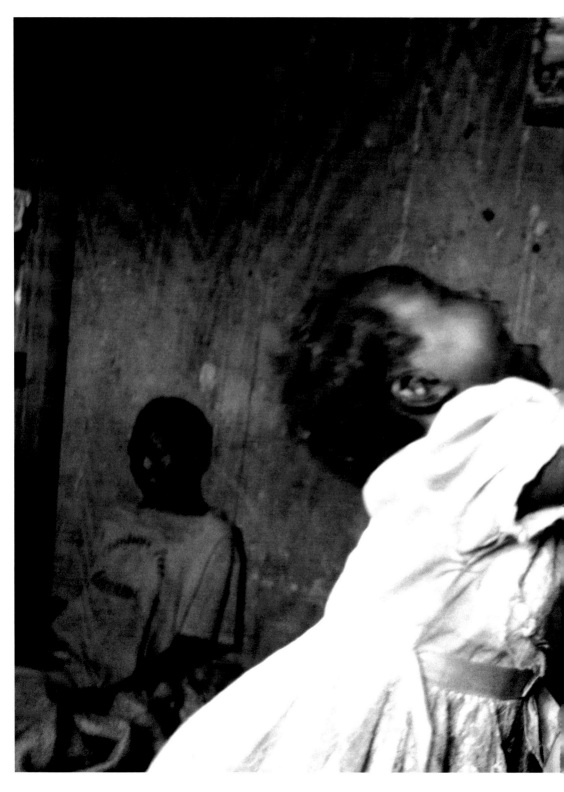

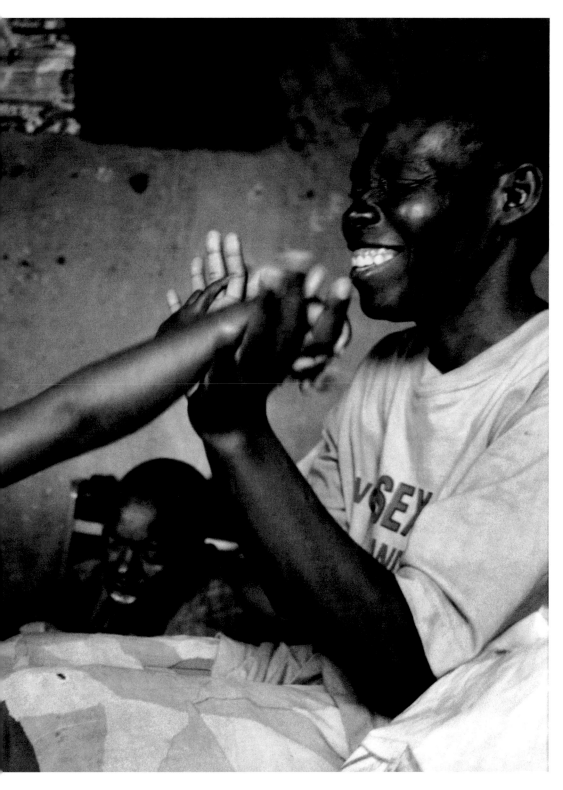

AIDS educators. Hlabisa, South Africa

At Hlabisa Hospital, a group of patients revealed their HIV status to the community and received training as AIDS educators. They promote sex education in their own and neighbouring communities.

I went to the hospital and they told me I had AIDS. At first I wanted to kill myself. A nurse spoke to me and asked whether I wanted to see other people with HIV, so that I would not be alone with this disease. Six of us met at Hlabisa hospital. We found that we gained strength just from knowing each other. I was trained as an AIDS educator with the other members of the group. I gained confidence to tell people about the virus. I demonstrate condoms at local health clinics.

Now I am healthier and gaining weight. Sometimes I even forget that I have the HIV virus. My husband Jaconia is fighting the disease with me, and our relationship is strong.

JABU SHEZI

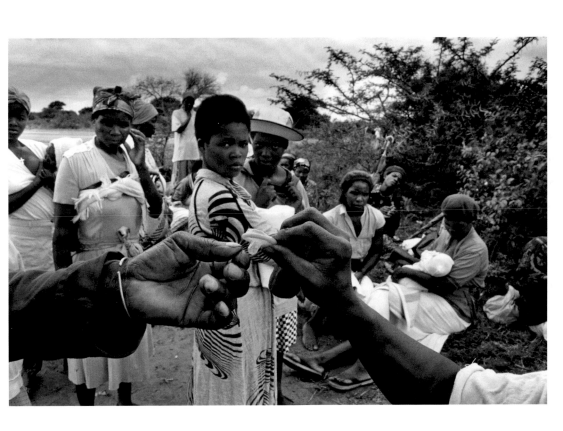

When my wife Jabu told me she had this disease it felt like the end. Then I thought about it and saw that it was not like that. I have learnt to live with the disease and now I have come to love my wife more and more. It does happen that I do have girlfriends, but now I use a condom. You can feel it just as well. It's the same as flesh to flesh.

I don't know when the time will come when AIDS is going to kill me. I feel under pressure and that's why I am building this new home for my children. I want to finish it soon as I am losing weight and getting weaker.

I taught myself to play Zulu guitar when I was younger and I've written songs about AIDS to warn people about the dangers. My 15-year-old son now plays bass with me. I hope my songs will stay with him when I am gone.

JACONIA SHEZI

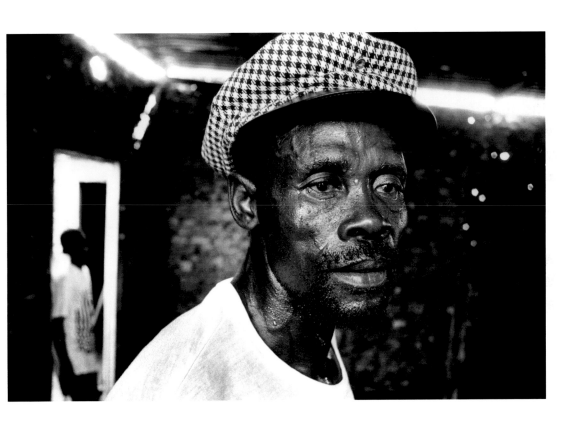

I must have caught the disease when I was living in KwaMashu, in Durban. I was selling clothes and had many girlfriends, so I don't know exactly who gave it to me. I wish I had been told about condoms and AIDS. I am a young man and I should have my whole life ahead of me.

My family is poor. When we came to this area we had to build these huts to live in. The ground is very dirty round here, but it is important to me that I look smart when I go to town to teach people about AIDS or when I go to church. When I tell people that I have this disease they often can't believe it because I look so strong and well. Once, when I was teaching at a school, the pupils told me to come back when I was sick and only then they would be convinced. I could only shrug my shoulders. I have warned them. What else can I do? I am worried that many of the youth in South Africa will catch this disease.

GIDA MTHEMBU

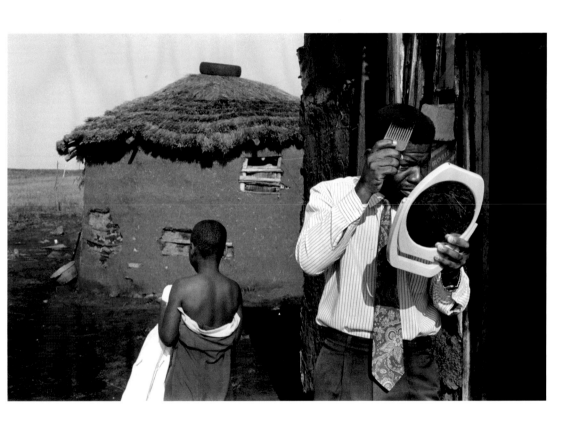

Queen Ntuli. Durban, South Africa

Active among traditional healers in developing AIDS education,
Queen Ntuli consults clients in her room.

I must start at the point where people accept AIDS
as AIDS and not a curse. I tell them that they must
practise safe sex and have a proper diet. I can give
them herbal treatment to boost their immune
system. I can give them counselling and tell them
what AIDS is. I tell them it is important to carry
on TB treatment. I teach about condoms and give
them out free.

I was taught about the disease at an AIDS
awareness workshop run by the Department of
Health in 1996. Some traditional healers who
don't want to attend workshops have been saying
that they can cure AIDS, but that is because they
don't understand what it is. They think that by
curing symptoms they are taking away the
disease, but they are wrong. It is bad for the
reputation of all healers when some make such a
claim. I know that in many cases I can help with
the symptoms of AIDS, but not the virus itself.
We can boost the immune system, but we cannot
cure AIDS.

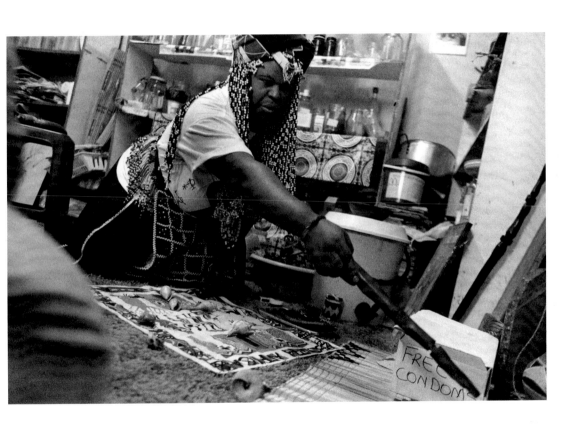

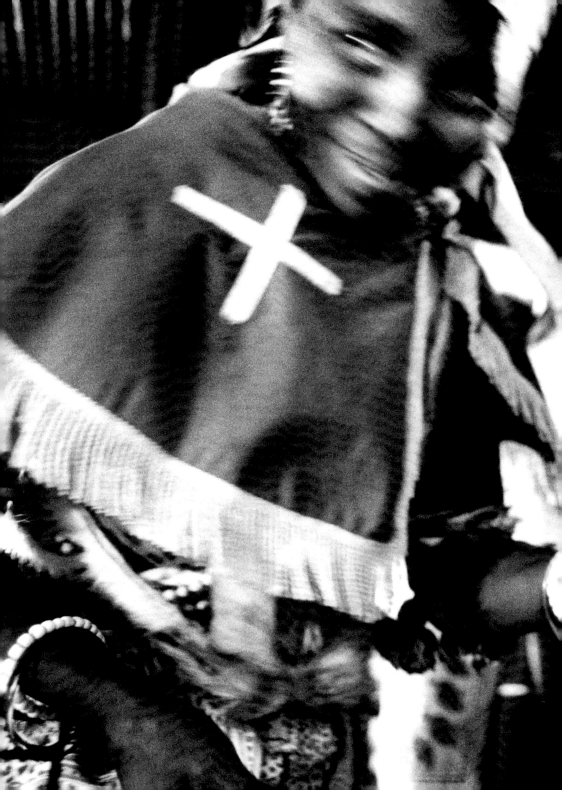

Peer education. Bukoba District, Tanzania

The Bukoba homecare team runs peer education programmes
as well as providing care for the sick.

We select people, often school pupils and members
of youth groups who are interested and willing
to teach others. They are taught about the trans-
mission of HIV and AIDS and sexually transmitted
diseases and discuss responsible behaviour
including use of condoms, delaying sex and
assertiveness in sex. We want to change high
risk to low risk behaviour. We also teach them
how to live with people who have HIV and to care
for AIDS patients, as most people in this region
have people who are ill in their family.

SPECIOSA RWAMAAG, NURSE, BUKOBA HOMECARE TEAM

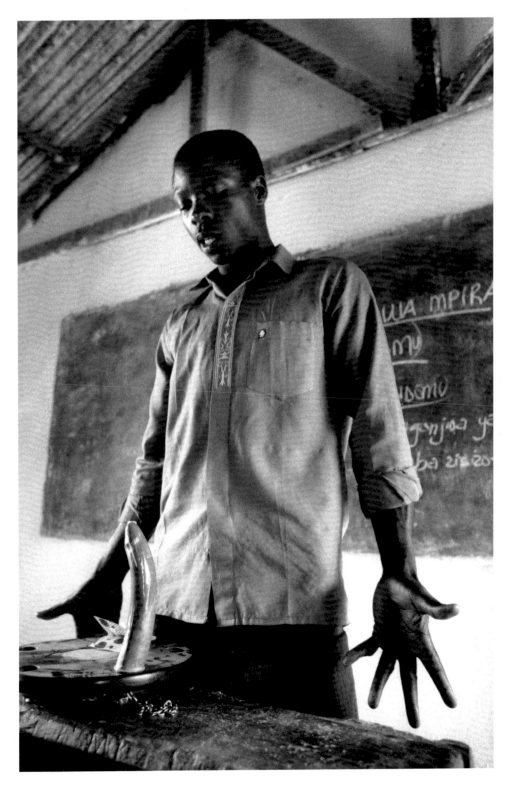

Angeningo Theatre. Pangani, Tanzania

Started by Pangani Hospital in 1997, the Angeningo Theatre Group uses drama to promote condom use and to prevent AIDS and sexually transmitted diseases.

We work out our plays in a way that invites the audience to participate. For example, there's a place where the girl in the story wants to have sex with her boyfriend for the first time because she loves him and does not want to lose him but he refuses to use a condom. She turns to the audience and asks them what she should do, to get their advice. Half the audience tells her to run away from him, and half tells her she must do what he says. People laugh a lot and it's very noisy! In the story she does then have sex with him, and contracts HIV and AIDS, and dies.

Drama is a good way of giving AIDS education to the community. We try to visit each village in the Pangani district at least once every three months. Now people have much more knowledge. We have identified increasing condom use, but you still can't say that we are safe. We are 12th in the country in terms of levels of infection.

DR. ZUBARI MIHUNGO, DIRECTOR, PANGANI HOSPITAL

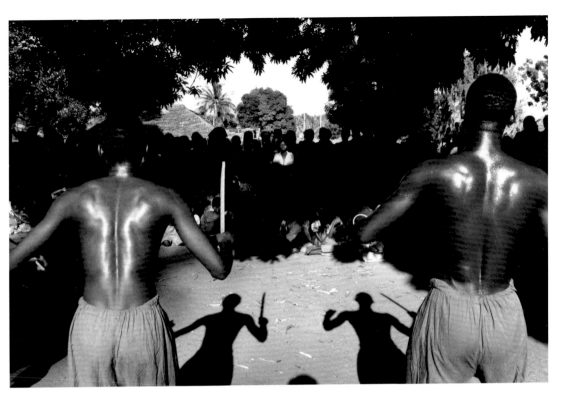

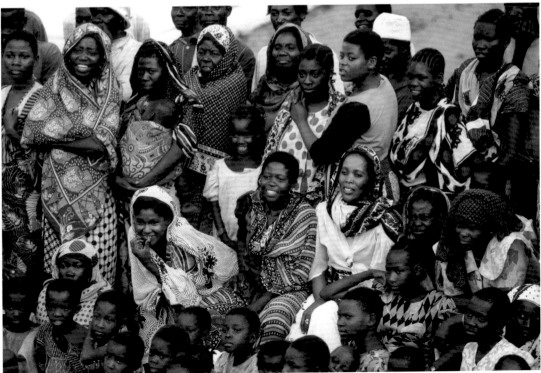

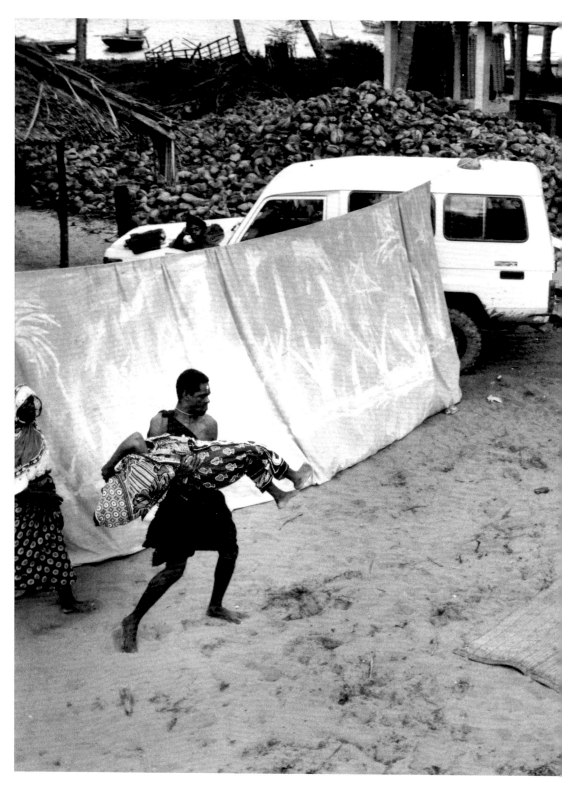

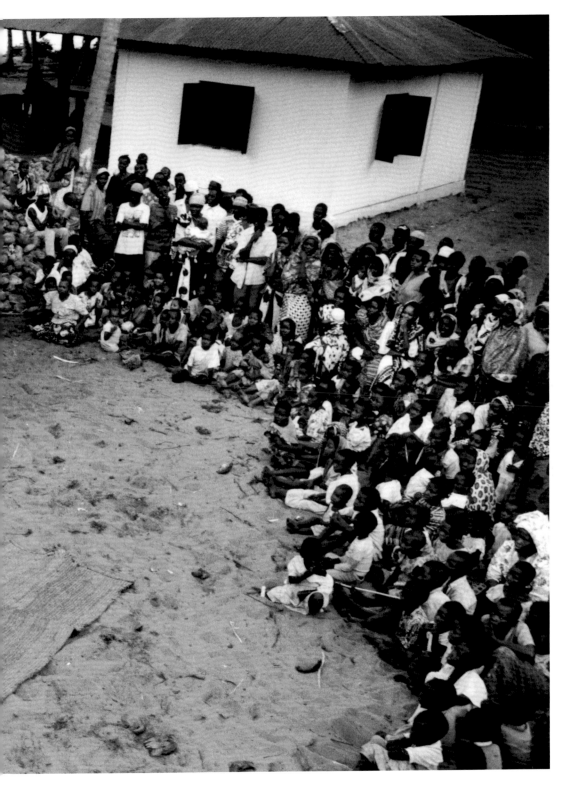

Florence Kumunhyu. Iganga, Uganda

Florence lost her husband in 1990 to the illness then known as 'slim'.

It took a long time after my husband's death in 1990, but I did build up confidence in myself and I decided to start a group here in the Buwolomera district of Iganga – the Buwolomera Development Association. The goal is to teach our people about this disease. We currently have 20 women members and three male members. Most of us are living with HIV and I have encouraged others to go for the test and then join us.

Men are more reluctant to join. Some of them are still interested in sleeping around so they think that if they joined us people would know that they are infected and no one would sleep with them. Still, I believe that if I can at least teach the women, then they can go back home and teach their husbands what they have to know about AIDS.

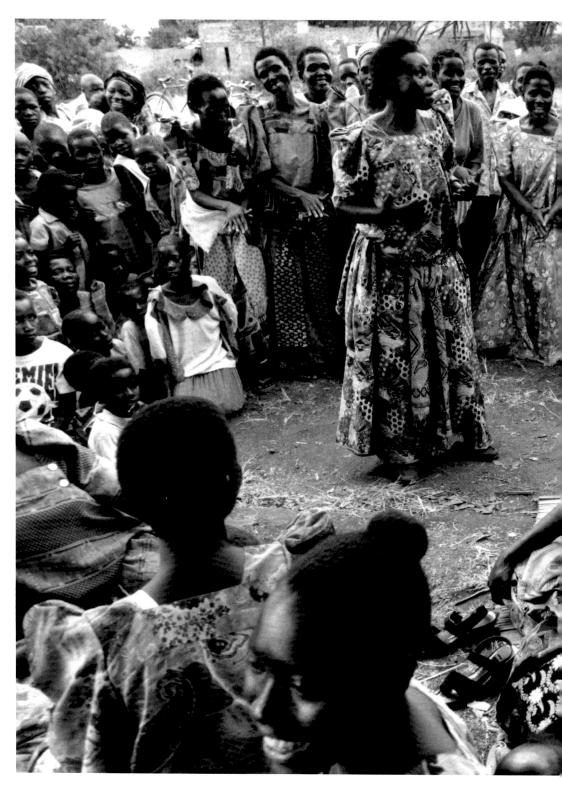

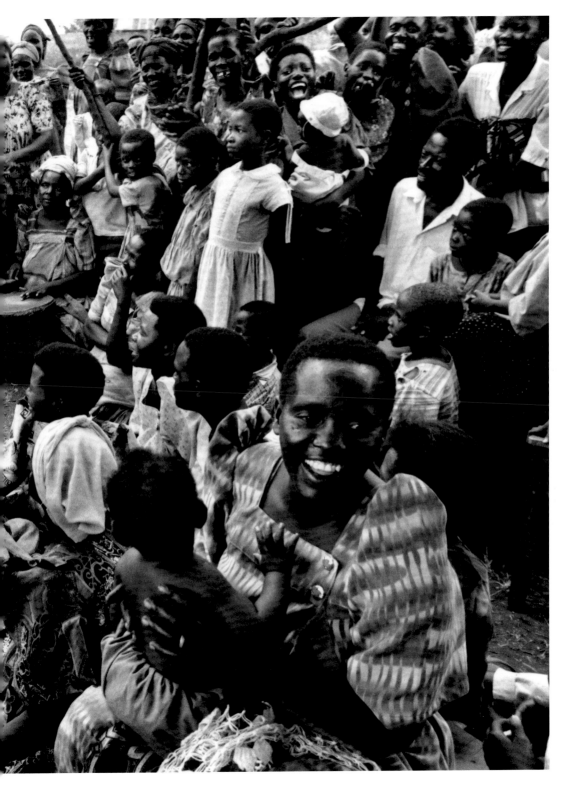

After my husband died, I was not at peace with myself because I wanted to know whether I was safe or whether I also had AIDS. I got inspired from some people in the church and decided to go for an HIV test. I was very shocked when they told me that I had HIV. I was very sad and cried a lot because I thought it was time to die. My children were still very young and immediately I began wondering who was going to look after them.

I decided to tell people around me that I had this disease. I was a young widow with eight children to look after. Although I knew many people would turn against me, I felt I had nothing to lose. I needed to find people who would help my children. Many people laughed when I told them that I had the disease. They used to say behind my back 'that woman has AIDS' as I walked in the village. My brothers-in-law were particularly difficult. Some of them wanted to remarry me and when I told them that I had HIV, they said I was lying to avoid them. They got angry and one of them tried to chase me away from my late husband's land.

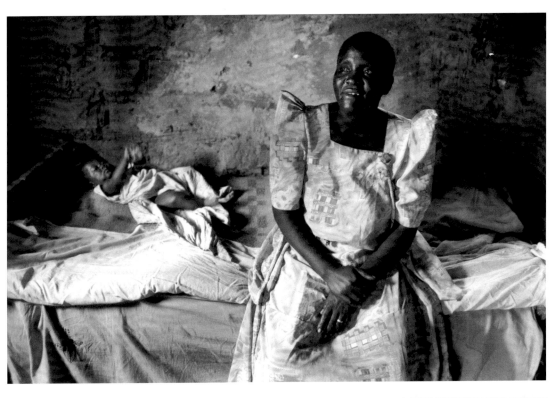

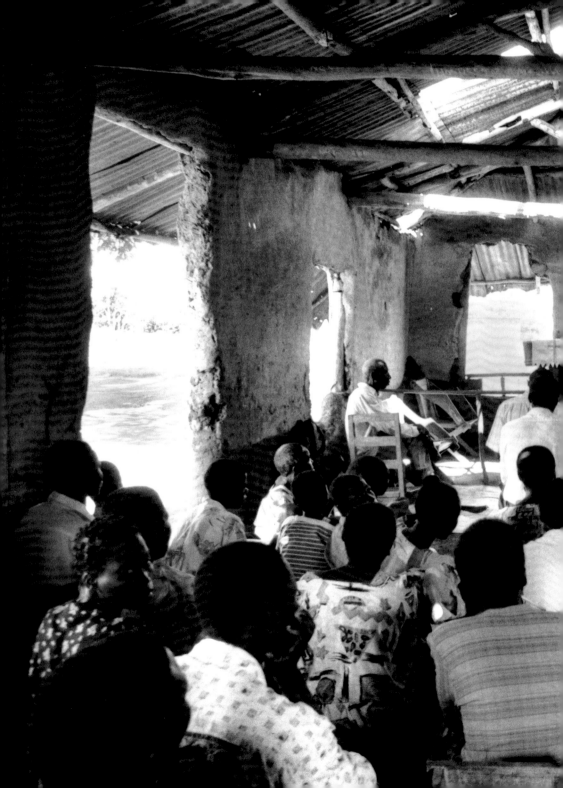

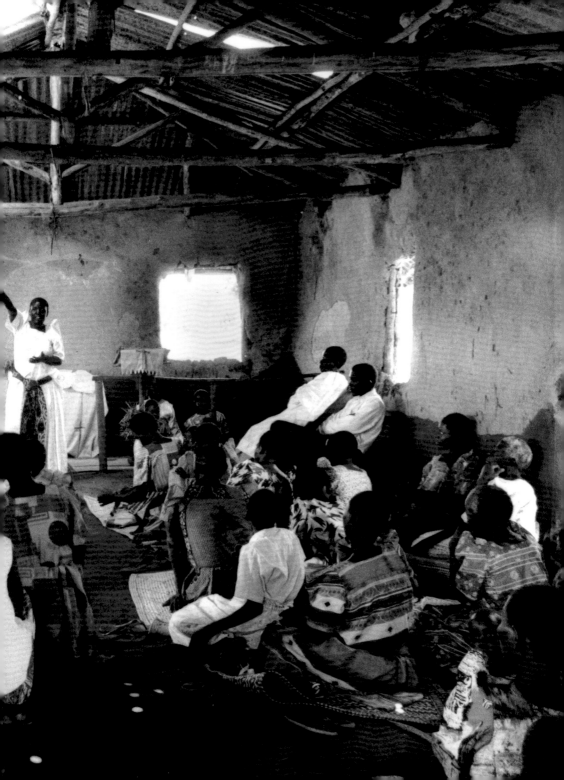

This disease grips us tight
Dear colleagues, sit and listen to us
The disease came determined to wipe us out

What shall we do, we unmarried girls?
Take a test, take a test with your admirers

What shall we do, we unmarried boys?
Take a test, take a test with your fiancées

The disease has come to wipe us out, take
precautions

Who are you, the ones affected by this disaster?
We are from Iganga
The disease came to Kampala, to Jinja, to Iganga
and everywhere
Take a test all of you, take a test
And let all your partners take a test
For the disease is real.
FLORENCE'S SONG

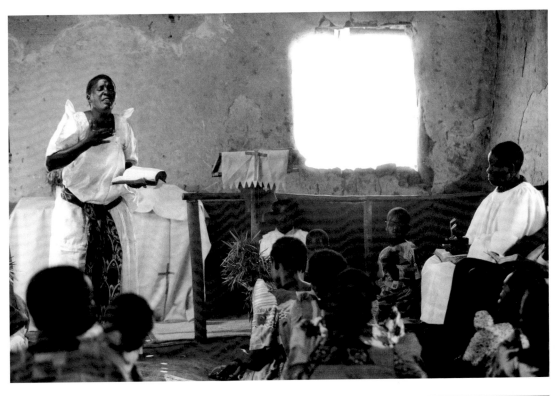
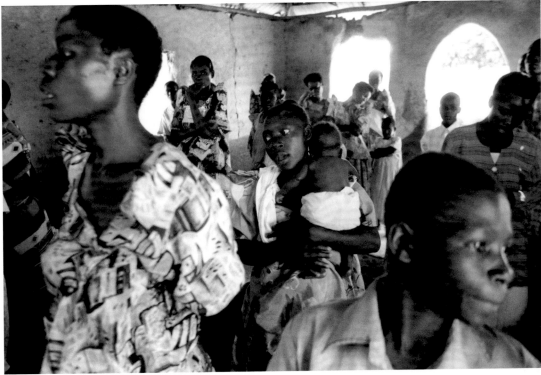

Susan Atuhura. Kampala, Uganda

Susan (16) started the Straight Talk Club at the City View High School in Kampala. The club is named after Straight Talk, a newsletter for young people about sexual reproductive health published in Kampala.

I realised that I did not know as much as I need to know about HIV and AIDS, and when I asked my friends, none of them seemed to really know. I decided to form a club where we could learn from one another. My friends joined, and then other students from school. It is now one year old and there are 30 of us, and we meet once a week.

As teenagers we need people to guide us and teach us about things that can save our lives, yet many of our parents are too shy to tell us about sex and sexuality and give us the information we need. At the club we teach each other. We talk about everything. I have learned a lot from my friends. This has given me self-confidence, and I can speak my mind.

Since the club started, there have been no new pregnancies among the students in the school. I think it is really helping a lot.

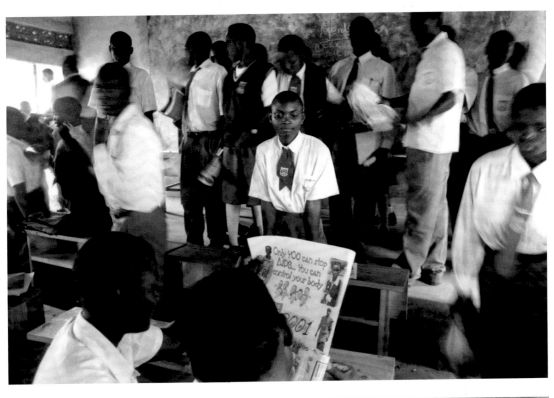

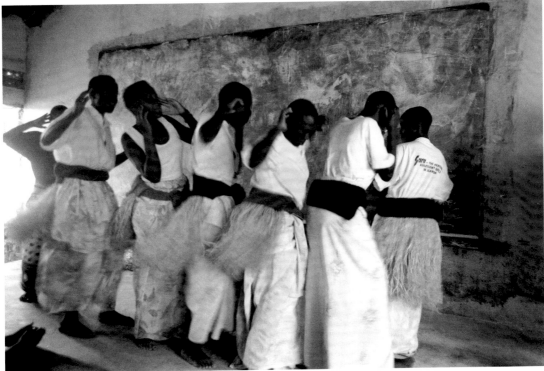

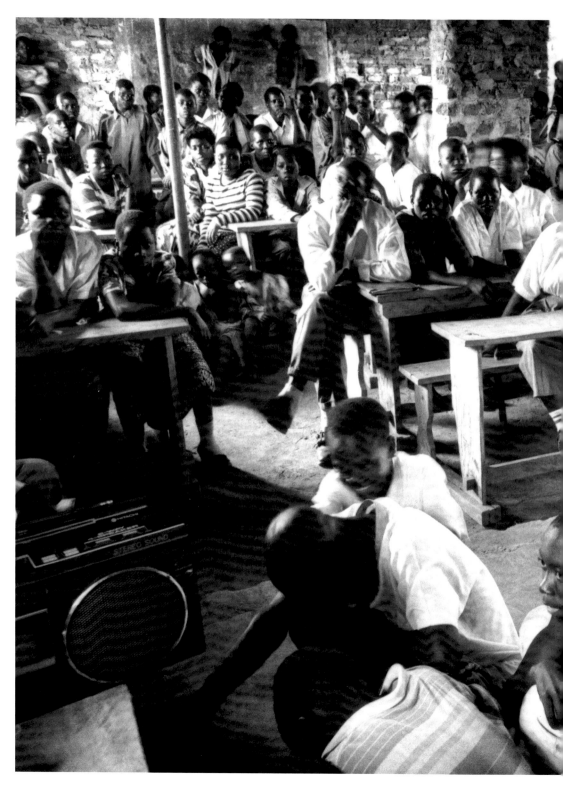

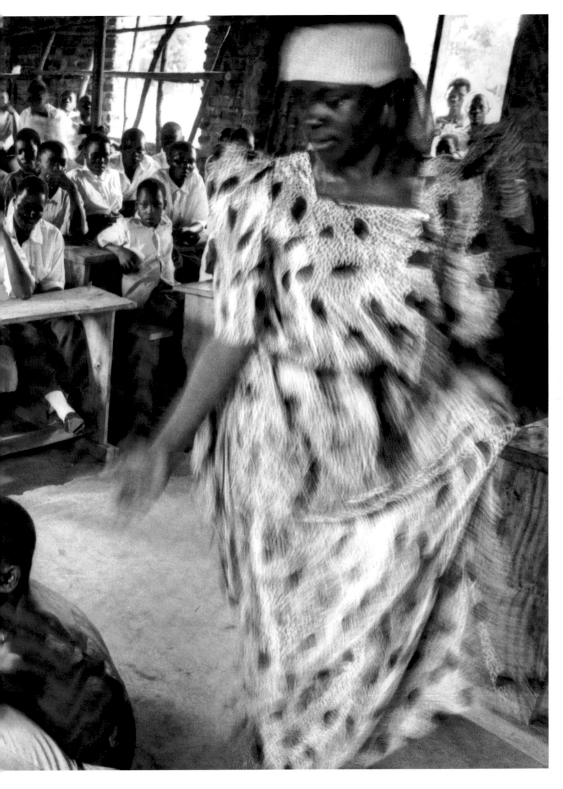

Anti-AIDS club. Lusaka, Zambia

1,800 anti-AIDS clubs have been set up in Zambian schools, including Munali Secondary School.

An anti-AIDS club is normally a voluntary after-school activity which takes place once or twice or a week. We encourage the schools to set the clubs up and we support them by providing some materials. The club members often take on the responsibility of trying to help educate the rest of the school and their peers about how best to avoid catching AIDS. The pupils who choose to get involved with the clubs are often very motivated. Many have had first-hand experience of the disease at home.

You have to see our efforts in the context of what is clearly happening with sexual activity among our youth. A recent survey showed us that 12% of the 15- and 16-year-old schoolgirls in Lusaka are testing HIV positive. It is vitally important to educate our youth about the facts of how AIDS is spread and the importance of abstention, but also that if they do choose to have sex they should use a condom. The best people to pass the message on to young people are other young people.

PRISCA CHITOMFA, FAMILY HEALTH TRUST ANTI-AIDS PROJECT

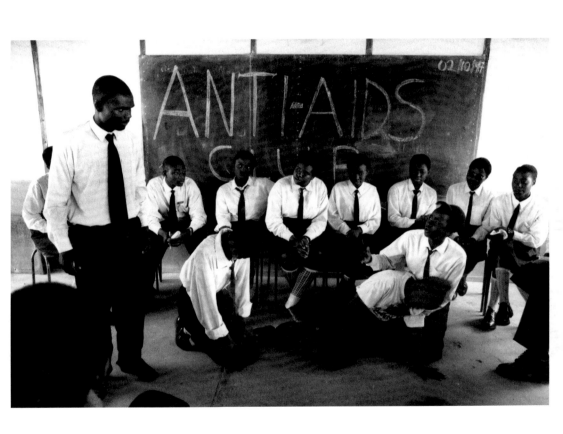

Nomhlahla Zungu. Ngwelezane, South Africa

Nomhlahla is a member of the Ngwelezane Hospital peer educators group.

I first had TB in 1994 but I didn't find out that I was HIV positive until 1998. When the AIDS counsellor at Ngwelezane Hospital gave me the information, she asked me how I would react if I was positive. I said that I was ready.

I decided that I wanted to live positively. My mother did not believe me at first. She only believed it when I began talking to the public. Then she was worried because she thought I might be killed. But people are not being hostile to me. Perhaps many of them know or worry that they might be positive as well, so they respect my decision to reveal myself which I have done to try to help educate my community.

The peer educators group is strong. We do con-certs and workshops and talks in the community, and go on outings like to the beach. We support each other.

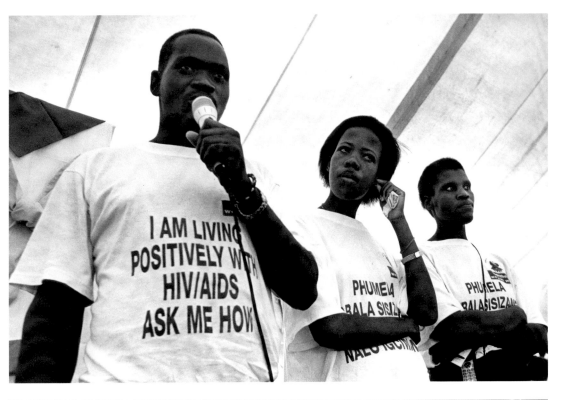

Fazeko Kuzwayo. Durban, South Africa

Fazeko is founder and member of Positive Voices, a choral theatre group of people who are HIV positive.

At the age of three my mother and myself followed my father into exile, where he was the ANC special representative in Lesotho. I was an ANC activist as a teenager, so when I found I was HIV positive, it was natural to become an AIDS activist.

Recently I was the Master of Ceremonies at a candle-lighting service held at the Durban City Hall. My message was simple – the silence is deafening, it must be broken. It was an emotional experience for me as my mother was one of the speakers whom I had to introduce. She spoke there as a person affected by AIDS. The title of her speech was 'Do I love her enough?' She was asking whether she brings enough laughter and joy into my life. It was difficult to introduce her because I was crying so much.

If I had one wish it would be that my father could still be alive. If he was around I could shout at him about the ANC's policies on AIDS.

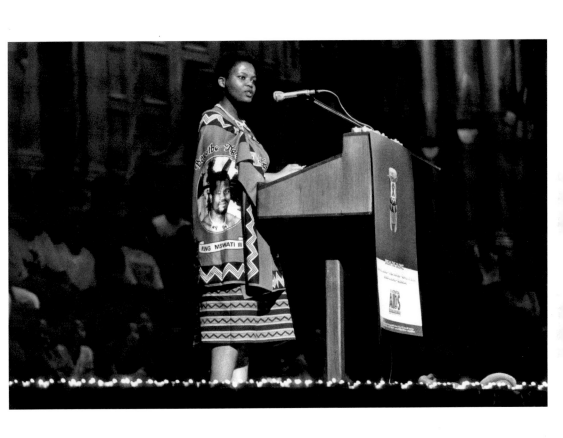

Reverend Gideon Byamugisha. Kampala, Uganda

Reverend Gideon is a priest in the Church of Uganda and head of the HIV/AIDS programme at Namirembe Diocese. He was the first priest in Africa to declare he was living with HIV.

When I told the Bishop that I was HIV positive, rather than throw me out as I expected, he knelt down and prayed for me and told me that I had a special mission in the church.

We need to integrate HIV/AIDS into the day-to-day life of the church. Religious leaders should not only condemn unlawful sex but unsafe sex as well. That is what I want to advise. Some church leaders are embarrassed by talking about AIDS but if we are to succeed, we need to be aware that there is a lot of sexual activity happening in our communities. Even if we choose to have unlawful sex, we are still bound to do it safely. I am advocating a culture where safe sex can be made easy, acceptable and routine.

It isn't always easy to be open. One time I went to Rwanda where I was not allowed to address a Christian rally because of my HIV-positive status. My daughter has been taunted at school. But most of the time it is OK. I buy condoms in the local shops and sometimes people see me and say 'Hey, here is a reverend buying condoms!' I just say 'Don't be excited. I am a person living with HIV. I am married, that's why I need to buy condoms.'

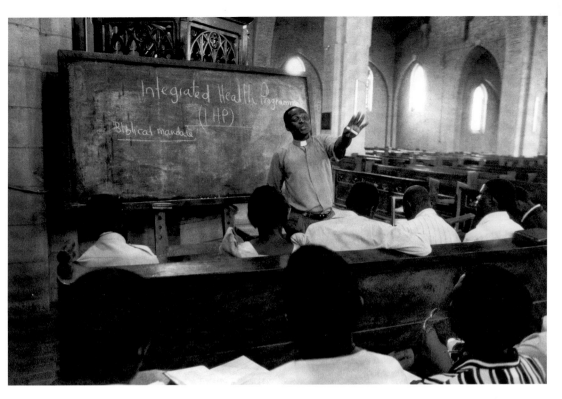

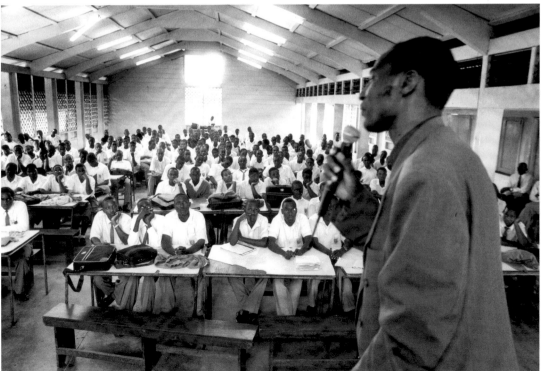

→ Blood

→ Semen

→ Vaginal

Sweat
Saliva
Pus

AIDS youth rally. Chinhoyi, Zimbabwe

Organised by the community group Batsarai (from the Shona word meaning 'help'), the Mashonaland West Province Youth Rally aimed to promote HIV/AIDS awareness and prevention among young people.

In Zimbabwe the national HIV infection rate is 25% and we believe that at least a thousand young people get infected every day. That is why it is so important to involve the youth in a serious way. They are our window of hope in the HIV/AIDS problem. We realise that the majority of the youth are still not infected so our approach is to get the information to them before they get the virus.

The youth festival in Chinhoyi was a big success. We wanted to motivate the various groups already involved and attract other youth to be part of the programme. The festival began with a march headed by 35 drum majorettes through the town centre wearing some great T-shirts. We had messages like 'Sex Doesn't Guarantee Marriage', 'Avoid Sex, Drugs and Sugar Daddies' and 'Give in to Sex and Get Dumped'. We want to empower youth so that they abstain from sex and postpone sexual activity. It was an impressive march. In the stadium there was drama, poems, dance, music and gymnastics. 3,000 youth attended and as a result we have managed to form 15 new youth groups.

DANIEL GAPARE, DIRECTOR, BATSARAI

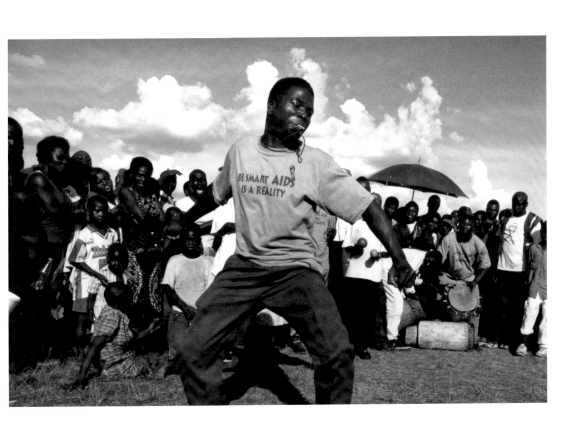

Treatment Action Campaign. Durban, South Africa

The Treatment Action Campaign march at the International AIDS Conference 2000.

The importance of this march historically is that it helped to change international perceptions. The image of AIDS in Africa is usually one of powerless people, emaciated and dying. What the march showed is that there are many of us who are healthy and fighting to stay healthy. In South Africa our work has started to bear fruit. Anti-retroviral treatment in the private sector has come down from 3,500 to 900 Rand per month. That is still not low enough for most people in South Africa but it shows the power of collective action.

I personally have made the choice as an activist not to take anti-retroviral medication until it is available to everyone. The vast majority of people who have HIV are poor. For me it is an issue of conscience. I cannot find myself living in a world where the government, drug companies and the international community stand by while there is a holocaust against poor people. But this is not a pessimistic stand. It is based on the belief that if we show resolve in our struggle we will get access to anti-retrovirals for people with HIV and quality health care for all people.

ZACHIE ACHMAT, TREATMENT ACTION CAMPAIGN CHAIR

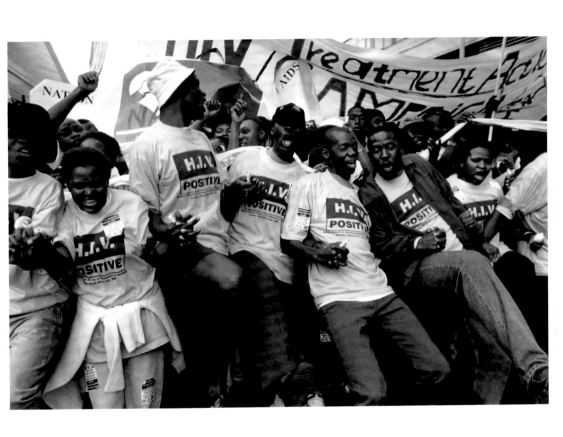

Breaking the Silence conference. Durban, South Africa

Zulu dancers perform in front of Durban City Hall during the 2000 International AIDS Conference.

Something must be done as a matter of the greatest urgency. And with nearly two decades of dealing with the epidemic, we now do have some experience of what works.

The experiences of Uganda, Senegal and Thailand have shown that serious investments in and mobilization around these actions make a real difference. Stigma and discrimination can be stopped; new infections can be prevented; and the capacity of families and communities to care for people living with HIV and AIDS can be enhanced.

The challenge is to move from rhetoric to action, and action at an unprecedented intensity and scale. For this there is need for us to be focused, to be strategic, and to mobilize all of our resources and alliances, and to sustain the effort until this war is won.

NELSON MANDELA (FROM HIS CONFERENCE SPEECH)

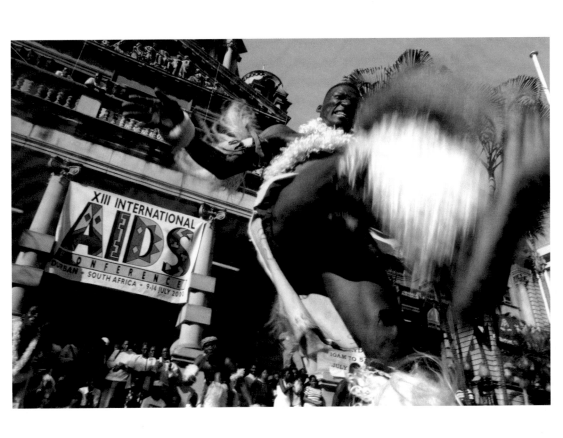

Reverend Gideon Byamugisha. Afterword

By talking about AIDS in Africa, people should not get the idea that the problem is 'out there'. That's a lie. We are in a global village and AIDS is everywhere. It is not just in Africa and it is not an African problem. If war is in Kosovo, don't imagine AIDS will not spread because Kosovo is part of Europe, not Africa. If people do not know how to read or write, if they lack self-esteem and are not able to participate in the information society, AIDS will spread among them just as easily if they are in America as in Uganda. When someone doesn't have enough to eat they will find it hard to protect themselves against HIV/AIDS, and if there is no access to condoms when someone wants to have sex, they are not going to be protected. If people don't earn enough money to be in a position to take decisions about their own life, or if women are powerless, they will have a problem saying 'no' to unsafe sex. AIDS flourishes everywhere these conditions exist.

AIDS isn't just a disease. It is a symptom of something deeper which has gone wrong within the global family. It reveals our broken relationships, between individuals, communities and nations. It exposes how we treat and support each other, and where we are silent. It shows us flaws in the way we educate each other, and the way we look at each other as communities, races, nations, classes, sexes, and between age groups. AIDS insists that it is time for us to sit down and address all the things we have been quiet about – sexuality, poverty, and the way we handle our relationships from the family level to the global level.

This book is talking about AIDS in Africa but the response to AIDS has to begin at the individual level, wherever we live. Before thinking about other people, ask the question: What about me? Am I at risk? How is my sexual life? How has it been in the past and how is it in the present? Could I be HIV positive but not know it? Do I know everything

I need to know about how HIV is transmitted? The answers to these questions inform where we stand on the issues. If I am negative, how do I protect myself so that I stay negative? If I am positive, how am I going to protect myself from disease, and get the services I need?

The next level of response is in relation to the family. Am I putting my family at risk in any way? If I am a parent, have I taught my children enough about HIV/AIDS? Do they know how to prevent it? Have I built up their self-esteem so that they can say 'no' to unprotected sex and have the confidence not to engage in things that make them vulnerable to disease? If they are not abstaining from sex, am I providing them with enough help and guidance?

At the village or community level, there are many questions responsible citizens should be concerned about. If someone in the community is positive, where do they go? Can people find out easily whether they are positive or negative? Does my community have a support group for people with the virus and a homecare service for people who are sick? Are there mechanisms for making people in the community aware about the issues of HIV/AIDS? Are people in the community encouraged to be open about their status, with community leaders speaking out against stigma and prejudice? Maybe there is more that can be done. I have seen advertisements saying 'Beware AIDS, AIDS kills' on the side of the road, but I have never seen them in a hotel which is where sex takes place. There is denial in the community. How can I help root it out?

Then you get to the government level, where the issues are the same but on a bigger scale. There are 22 million people in my country, Uganda. How many are infected, how many are not? With those who are already infected, what do I do for them? What do I do to help those

who are not infected to remain uninfected? What policies are needed to ensure that infections don't increase? What can I do to alleviate those factors that promote the vulnerability of my people, like illiteracy and poverty, cultural problems, gender disparities? What part can I play to help the government deal with these questions?

Starting to think about the issues as a member of the global village, the question arises as to why AIDS is concentrated in some nations and societies and not others. What is promoting AIDS infections in the communities that are worst affected? What is causing inequality?

Very soon one discovers that what these societies have in common is poverty. They experience unfair trade policies and face huge debt repayments. Within continents and countries, AIDS thrives in communities which are marginalised and where groups of people are regarded as different by the rest of the society. They lack information and services. So now what do I do? Can I get information to the people who make a difference to the way the world runs?

Mending our broken relationships involves us in thinking not just as individuals or members of specific nationalities or tribes, but in recognising that what one does in one country affects people in other countries. What I spend here affects how someone else lives somewhere else in the world. What one does in trade and industry, the laws one supports in patents and copyrights, the way money is managed between nations – all these directly affect people's lives.

Because AIDS is a largely preventable and manageable disease, the main challenge is one of leadership. History will want to know who were the world leaders at a time when a preventable disease killed millions of people, debilitated millions of others, and destroyed

promising economies across Africa, Asia and Latin America. There has been indifference at the global level, but it is unfortunately true that this problem is at the local level too. Many local community and national leaders of countries heavily infected by the epidemic have not explored all the possibilities in HIV prevention, or in AIDS care and support, that could be used to end this epidemic. I know many communities whose leaders have never arranged a meeting, or worked on how their youth can be helped to escape infections, or how affected individuals can get basic care or treatment.

In Uganda we have been relatively lucky. The government has been willing to take risks and open up and say 'Here, we have a problem' while other governments were saying 'Ah, but if we open up maybe our tourism will suffer' or 'Maybe it is not going to be as bad as they say'. Uganda took the problem by the horns early on and it has paid off – now the level of infection is down from 15% to 8%. President Museveni had information early on because when he came out of the war and was training his army, most of his men were infected. He recognised AIDS was going to be serious. All parts of Ugandan civil society – the government, religious, health and community institutions – work hand in hand. The more the silence has been broken, the more the transmission chain also.

Many people in Uganda have made a contribution to the fight against AIDS, and it has made a difference. People are encouraged to share their HIV status and the community is willing to accept and care for people who are sick, to promote abstinence, to increase the acceptability of condoms. Even if people have the very minimum to survive, they will use what they have to help their brother or sister. It may not be enough but it is there. No-one is passive. If someone doesn't agree with one policy, they don't fight against it but will help

with another. And now in Senegal we have seen the great thing of AIDS being tackled before it became a serious problem, so that it has been reversed at the outset.

So we know that if there is commitment, openness, and a willingness to innovate and think outside the box, this disease can be contained. The suffering is not inevitable. New HIV infections can be prevented and people living with HIV/AIDS can be cared for and treated. When we look around, we see a lot of willingness at the global level to try to rectify what has gone wrong. The many summits and meetings which are taking place point toward working together and accepting our responsibilities to one another as members of the global village. History demands more, but we have started.

There is a tendency to portray AIDS as if it is too big a problem and one that we cannot do anything about. But we are not powerless, and the situation is not hopeless. 36 million people in the world are infected with HIV, but there are six billion people in the world. Of course it is possible for AIDS to get much worse, but it is within our power to ensure that it doesn't. We have the information we need. We have the means and the skills to make an impact. We have the money. Our job is to transform our broken relationships so that we are healed and united and strong.

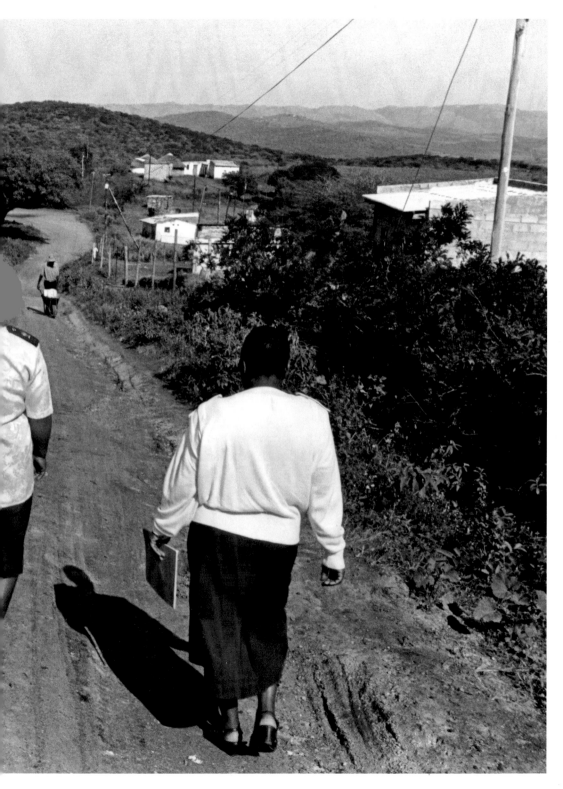

Resources

www.abrokenlandscape.com The *A Broken Landscape* website.

www.aidsmap.com AIDSmap is a central source of information about HIV/AIDS.

www.actionaid.org ActionAid works with poor and marginalised people around the world to eradicate poverty, helping them secure basic rights such as food, healthcare and education.

www.aidschannel.org Global portal on AIDS from the OneWorld network of civil society organisations working for human rights and sustainable development.

www.hsph.harvard.edu/hai The Harvard AIDS Institute is dedicated to conducting and catalyzing research to end the worldwide AIDS epidemic.

www.positivelives.com Through photography and personal testimonies, Positive Lives communicates responses to HIV/ AIDS around the world.

www.unaids.org UNAIDS is the United Nations advocate for worldwide action against HIV/AIDS.

www.undp.org The first Human Development Report was launched by the United Nations Development Programme in 1990.

www.stratshope.org Strategies For Hope promotes informed, positive thinking and practical action by all sections of society, in dealing with HIV and AIDS.

www.worldaidsnews.com Database of AIDS stories and information.

www.worldbank.org/wdr The World Bank's annual World Development Report is a guide to the economic, social and environmental state of the world today.

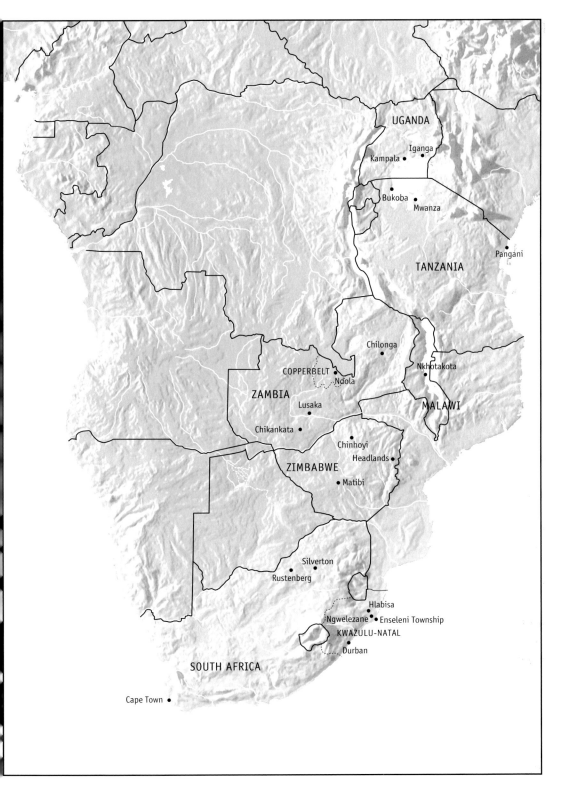

My work on HIV/AIDS in Africa would not have been possible without a long-term creative partnership with Positive Lives, its volunteers, and its partners the Terence Higgins Trust, Network and the Levi Strauss Foundation. I am indebted to the W. Eugene Smith Memorial Fund, ActionAid and the staff and photographers at Network.

Lyndall Stein has been an invaluable supporter, counsellor and friend over the years. I would also like to thank Chris Boot, Stu Smith, Carolyn Watts, Colin Jacobson, Neil Burgess, Mitchell Warren, Alice Wynne Willson, Nancy Khuswayo, Tim Manchester, Thoko Luthuli, Nick Partridge, Dr Peter Haselau, Joseph Cabon, Stephen Mayes, Mike Kemp, Jaqueline Batoringaya, Sister Gloria, Lesley Lawson, Captain Dean Pallant, Captain Lena Jwili, Dr Aschwanden, David Goldblatt, Dr Ros Coleman, Dr Mara Rossi, Amanda Stone, Kevin Ryan, Dr. Nathan Nshakira, David Nyirongo, Laurence Watts, Paul Kwangere, Sarah Stewart, Adam Hooper, Alick Mukuba, Mike Spry, Daniel Kalinaki, Joe Hanley, Glen Brent, Kevin Toolis, Rod Morris, Nicole Nogrette, Gary Wilson, Dr Ade Fukoya, Mia Diehl, Michelle McNally, Mark Porter, Peter Bussey, Vivien Hamley, Busi Chamane, Christian Aid, CAFOD, PSI, Fortune Magazine, the Guardian Weekend, L'Express and Kodak Professional. My partner Sarah Macauley was a source of inspiration and critical guidance throughout.

Behind every picture there are individuals, families, carers, organisations and institutions, too numerous to mention, whose practical help and kindness will not be forgotten. Finally I must pay tribute to the people I photographed, most of them living with HIV or AIDS, who welcomed me into their lives with such generosity and were brave enough to allow themselves to be photographed, believing that these images could make a difference.

Gideon Mendel, July 2001

First published in the UK 2001
This edition published in the USA 2002 by Art Blume in association with ActionAid
© Network Photographers Limited, 2001

Produced and edited by Chris Boot
Designed by SMITH
Photographs © Gideon Mendel
This edition has been made possible with the support of the Rockefeller Foundation.
www.abrokenlandscape.com

Art Blume, S.A. Av. Mare de Déu de Lorda 20, 08034 Barcelona, Spain
www.blume.net

Network Photographers 4 Nile Street, London N1 7ZZ, UK
www.networkphotographers.com

ActionAid 1112 16th Street NW, Suite 540, DC 20036-4823, USA
www.actionaid.org

$5 from the sale of each book goes toward ActionAid's work on HIV/AIDS in Africa.

ISBN 84-95939-11-8

Printed by EBS, Verona

Network Photographers **act:on**aid